Climb the mountains and get their good tidings. Nature's peace will flow into you as sunshine flows into trees. The winds will blow their own freshness into you. . .while cares will drop off like autumn leaves.

—JOHN MUIR

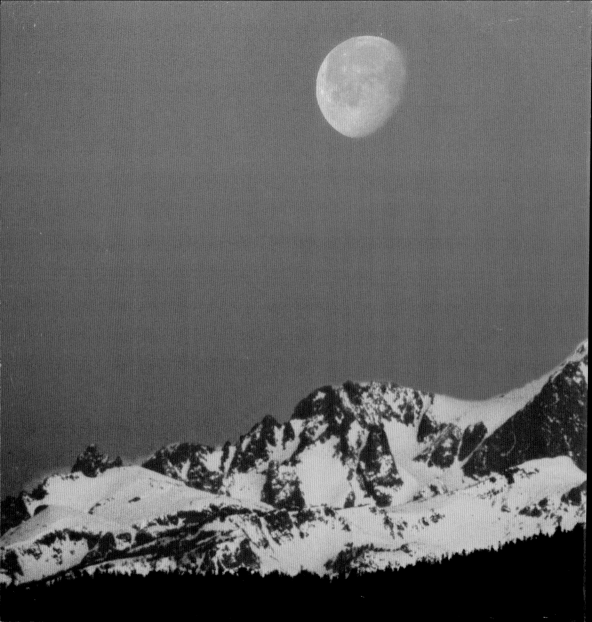

YOSEMITE
& the EASTERN SIERRA

PHOTOGRAPHS BY GARY CRABBE
EDITED BY PETER BEREN

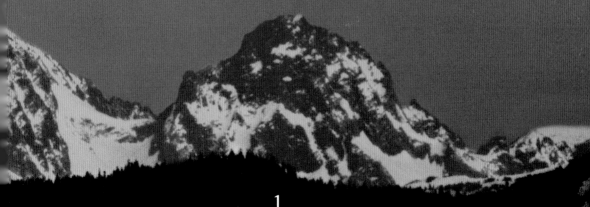

welcome
BOOKS

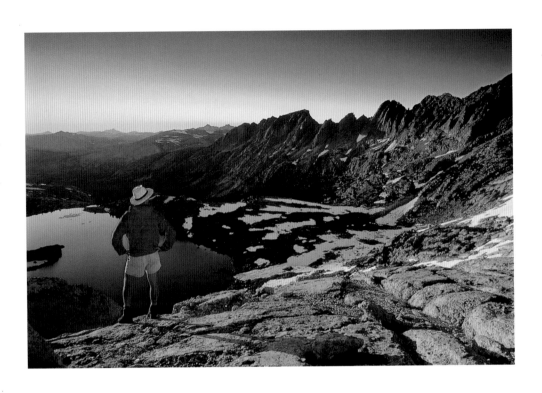

*To the continued legacy of John Muir
& the memories of Galen and Barbara Rowell*

The Sierra defies simple description. They need to be seen and felt underfoot. They need to be breathed in, not just as air into the lungs, but as a source of renewal for the spirit. Although young by geologic standards, the Sierra exudes a sense of timelessness, rugged endurance, solitude, and the peaceful harmony of nature.

One of my favorite views is a nearly hundred-mile stretch of the Eastern Sierra escarpment reaching across the horizon. In fact, I think no trip to the Eastern Sierra is complete without taking a side trip to the White Mountains and the Ancient Bristlecone Pine Forest. Seen from the highest elevations, the view back towards the Sierra spans the Owens Valley. Almost 10,000 feet below, it is nearly twice the depth of the Grand Canyon.

There are many purists who feel one needs to hike at least thirty miles into the High Sierra to truly appreciate the wild feeling of this majestic landscape. But I believe one of the greatest aspects of a visit to Yosemite and the Eastern Sierra is the accessibility to so many treasured features, locations, and vistas.

Yosemite and the Eastern Sierra, rugged and enduring as they may appear, are actually fragile landscapes loved and visited by millions. I hope the images and words in this book serve as inspiration for the special and unique magnificence of the Sierra. Moreover, I hope they help motivate more people, especially the visitors and users of the land, to care about its preservation and proper stewardship, so these scenes will still be available to our great-great-great grandchildren.

—GARY CRABBE

Moon over Mount Ritter and Banner Peak near Mammoth Lakes *(preceding spread)*
EASTERN SIERRA

Hiker at sunset on mountain pass above Upper McCabe Lake
EASTERN SIERRA

When I first
saw Yosemite, I knew I had
discovered my destiny.

—ANSEL ADAMS

Sunset light through a rain storm
YOSEMITE VALLEY

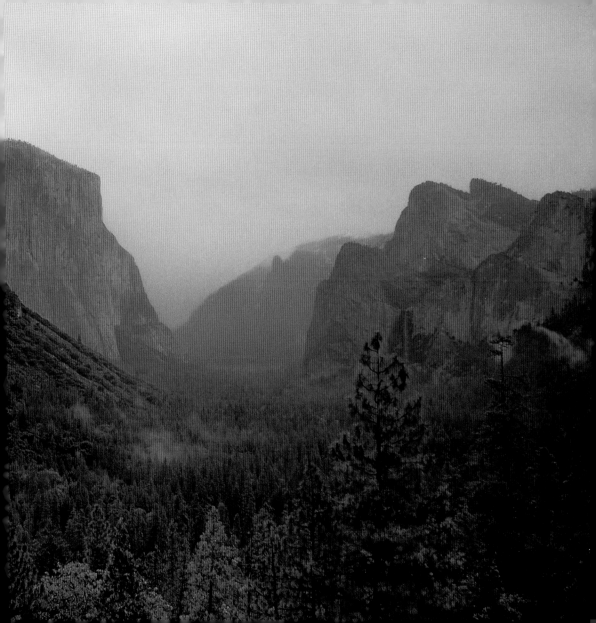

8

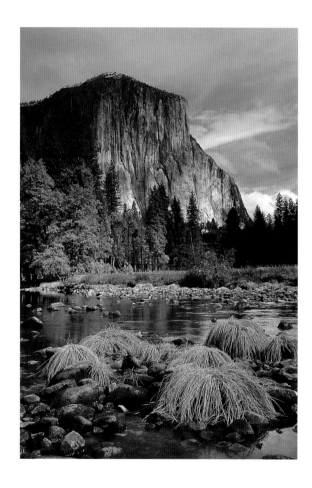

El Capitan over the Merced River,
Gates of the Valley
YOSEMITE VALLEY

Spring trees in meadow *(opposite)*
YOSEMITE VALLEY

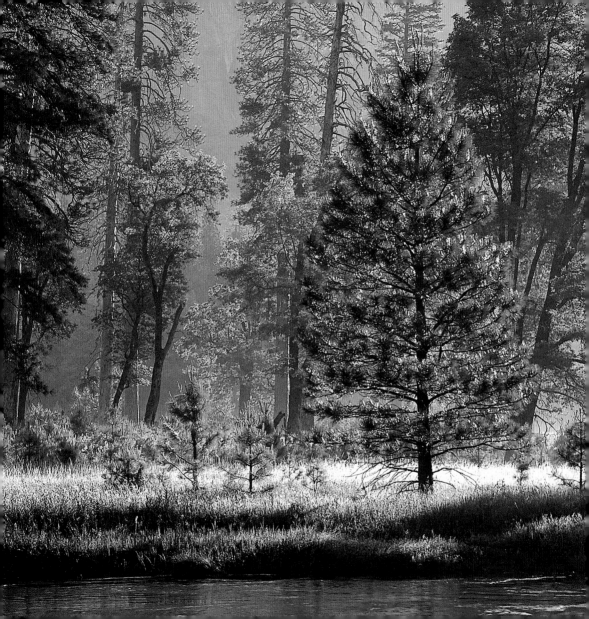

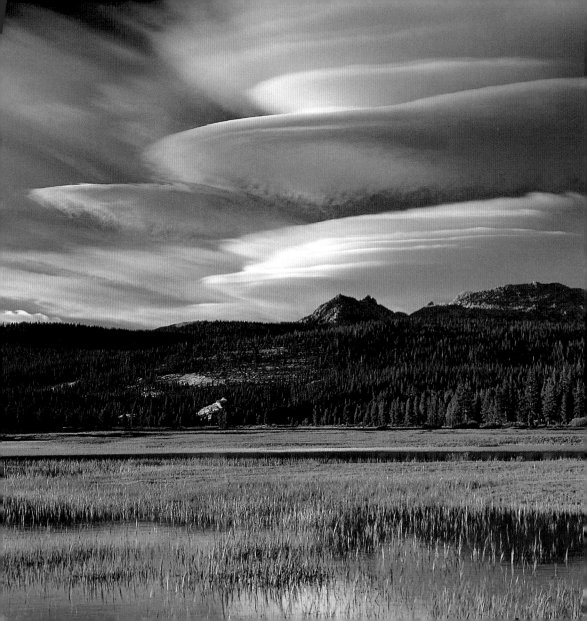

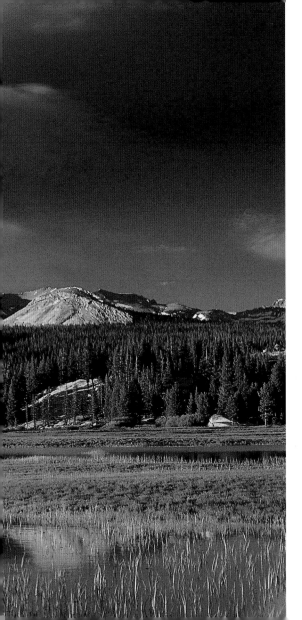

It is possible to pursue innocence. . .single-mindedly, driven by a kind of love, crashing over creeks . . .wide-eyed, giving loud tongue all unawares to the deepest, most incomprehensible longing, a root-flame in the heart, and that warbling chorus resounding back from the mountains, hurling itself from ridge to ridge over the valley.

—ANNIE DILLARD

Lenticular cloud over Ragged Peak and Tuolumne Meadows
TIOGA PASS ROAD
YOSEMITE NATIONAL PARK

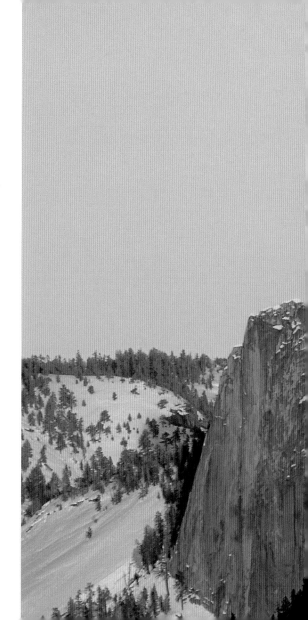

Winter sunset on Half Dome
YOSEMITE VALLEY

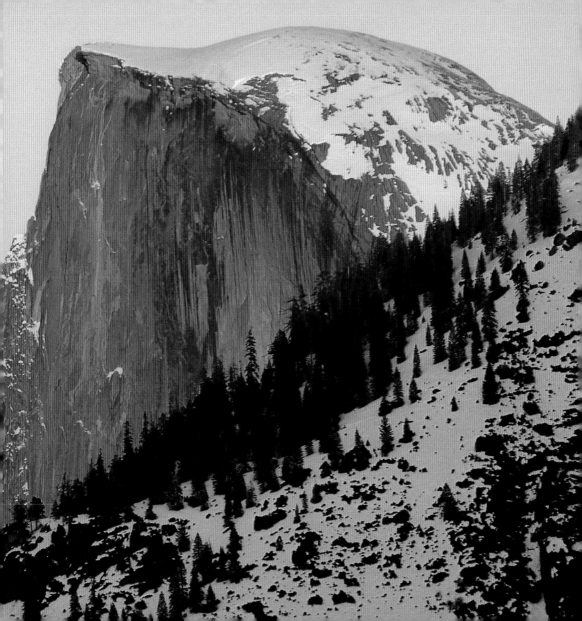

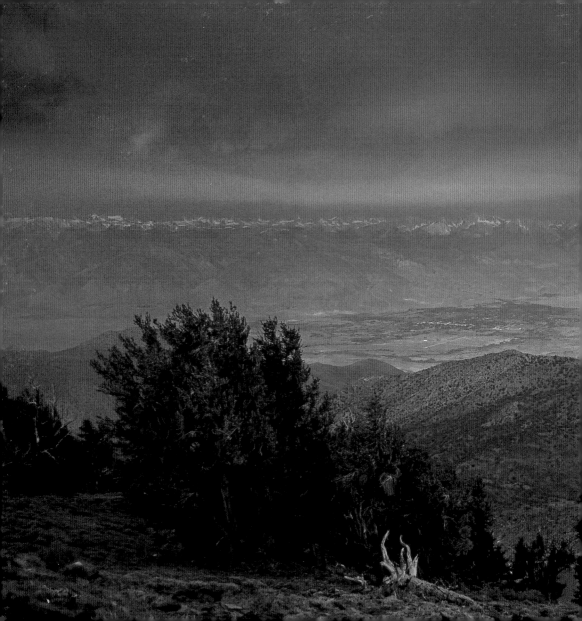

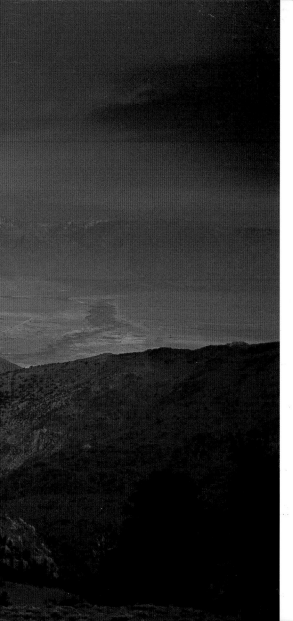

It is beyond
the power of language to
describe the awe-inspiring 15
majesty of the darkly-frowning
and overhanging mountain
walls of solid granite that here
hem us in on every side, as
though they would threaten us
with instantaneous destruction,
if not total annihilation, did we
attempt for a moment to deny
their power.

—J. M. HUTCHINGS

**Stormy dawn over the
Sierra Nevada and Owens Valley**
ANCIENT BRISTLECONE PINE FOREST
WHITE MOUNTAINS

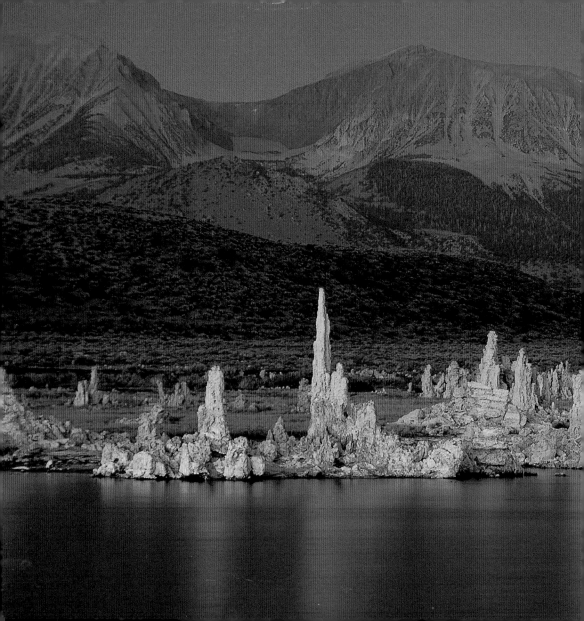

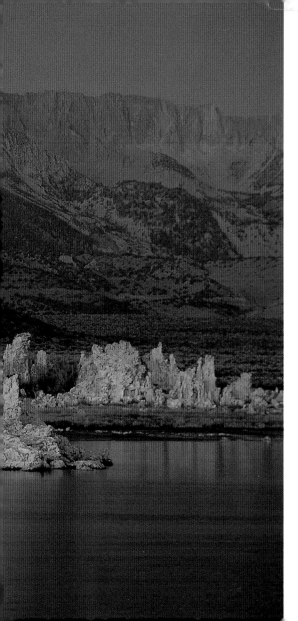

The last days
of this glacial winter are not yet
past… and the world, not yet
half made, becomes more
beautiful every day.

—JOHN MUIR

Tufa formations at South Shore
MONO LAKE, NEAR LEE VINING
EASTERN SIERRA

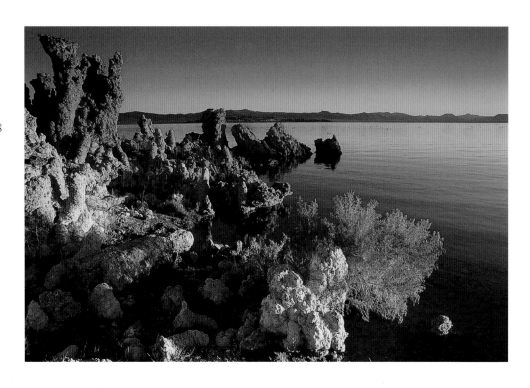

Calm waters and morning light on Tufa formations
SOUTH SHORE, MONO LAKE
EASTERN SIERRA

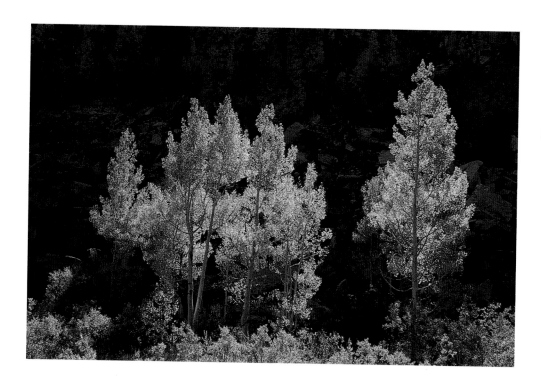

Aspens along the South Fork of Bishop Creek near Bishop
INYO COUNTY
EASTERN SIERRA

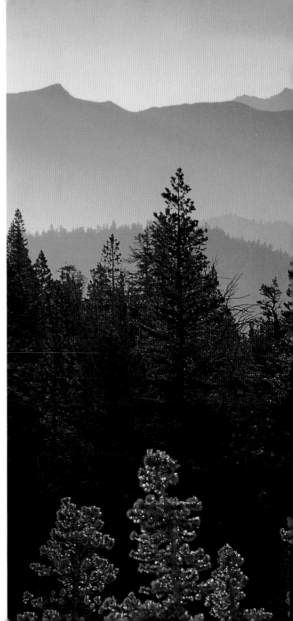

$$S_{itting}$$

20 islanded on some gray peak
above the encompassing wood,
the soul is lifted up to sing the
Iliad of the pines. They have no
voice but the wind, and no
sound of them rises up to the
high places.

—MARY AUSTEN

**Sunrise light over forest,
from Minaret Summit**
MONO COUNTY, EASTERN SIERRA

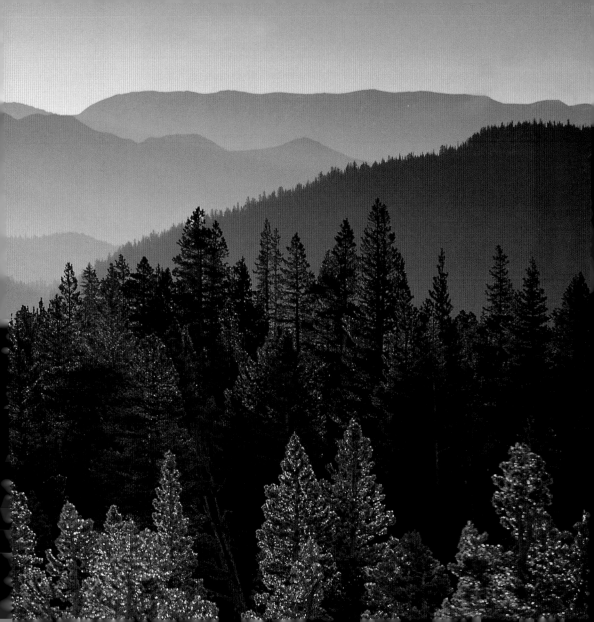

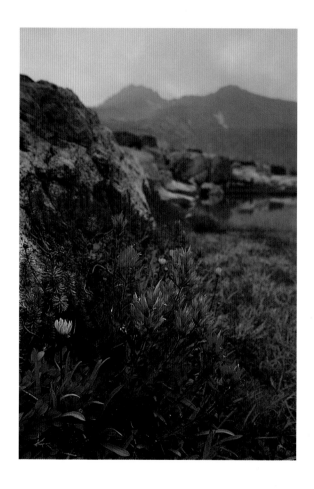

Indian paintbrush
at 20 Lakes Basin
EASTERN SIERRA

Alpenglow on Sierra crest
from Tuolumne Meadows (*opposite*)
TIOGA PASS ROAD, YOSEMITE

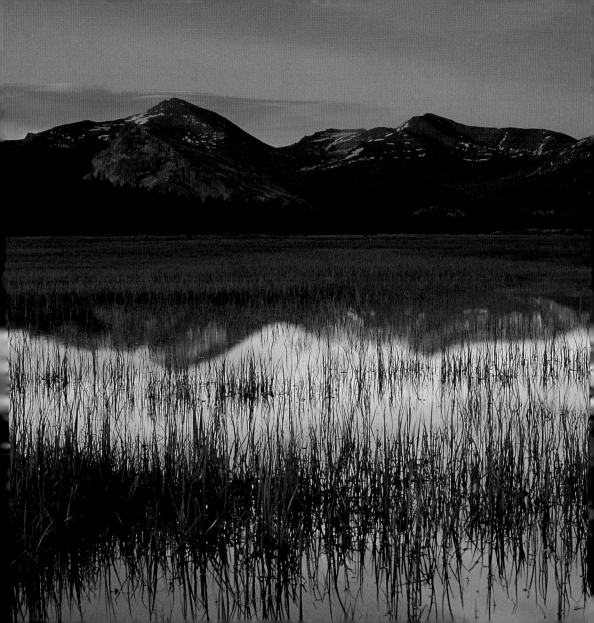

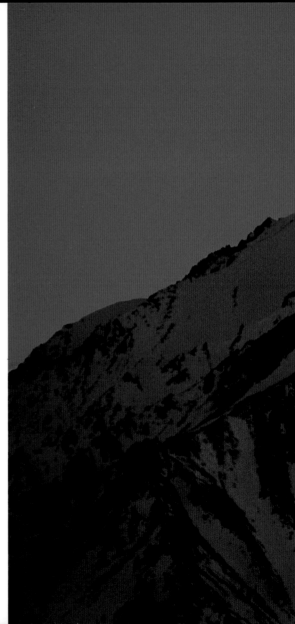

Alert eye
looking ahead, picking the
footholds to come, while never
missing the step of the
moment. The body-mind is so
at one with this rough world
that it makes these moves
effortlessly once it has had a bit
of practice. The mountain
keeps up with the mountain.

—GARY SNYDER

24

Last light on the mountain
NEAR BISHOP, EASTERN SIERRA

**Wind-formed patterns
in snow and ice** *(overleaf)*
NEAR LEE VINING, EASTERN SIERRA

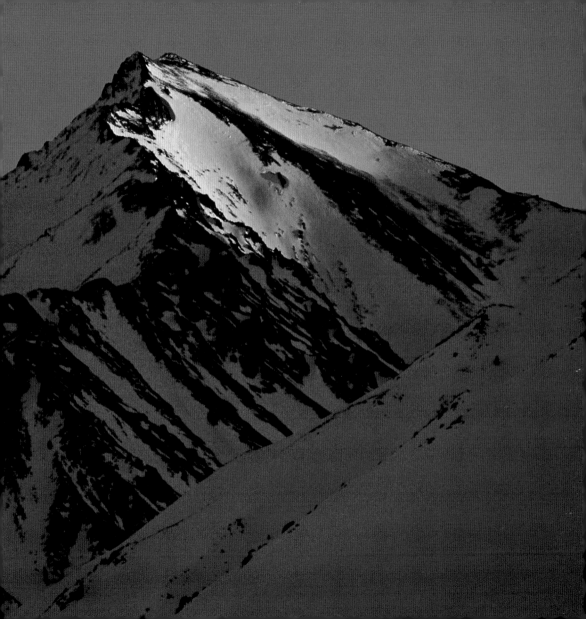

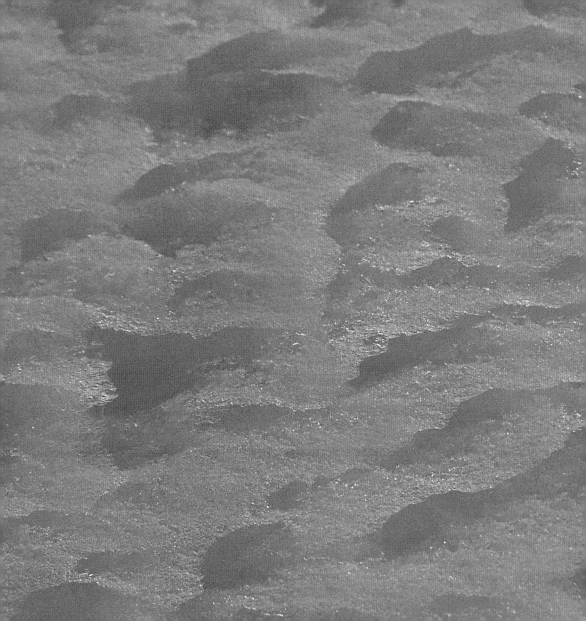

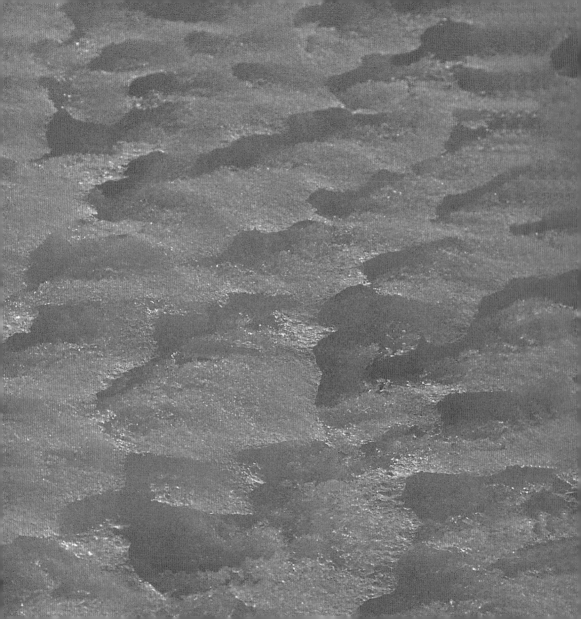

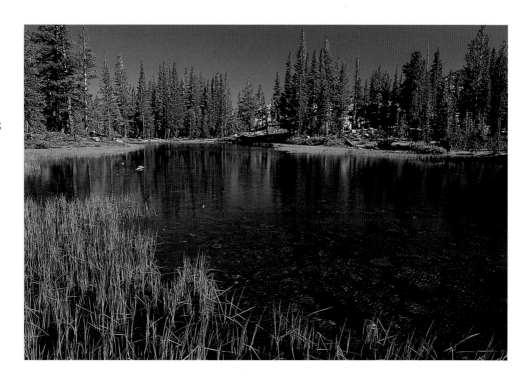

Clark Lakes area
ANSEL ADAMS WILDERNESS, EASTERN SIERRA

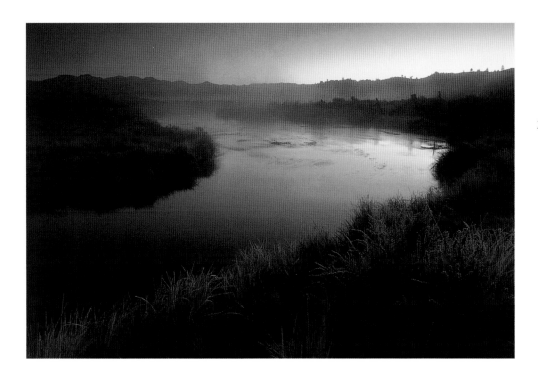

Sunrise at Hot Creek, near Mammoth Lakes
EASTERN SIERRA

It was the
grand whole that bewildered
and overwhelmed us.
Whatever of majesty that is
made up of imaginable
strength and massiveness was
there. Whatever of sublimity,
inconceivable height and
unsounded depth can give
was there.

—MARY CONE

Cathedral Rocks reflection
in springtime
YOSEMITE VALLEY

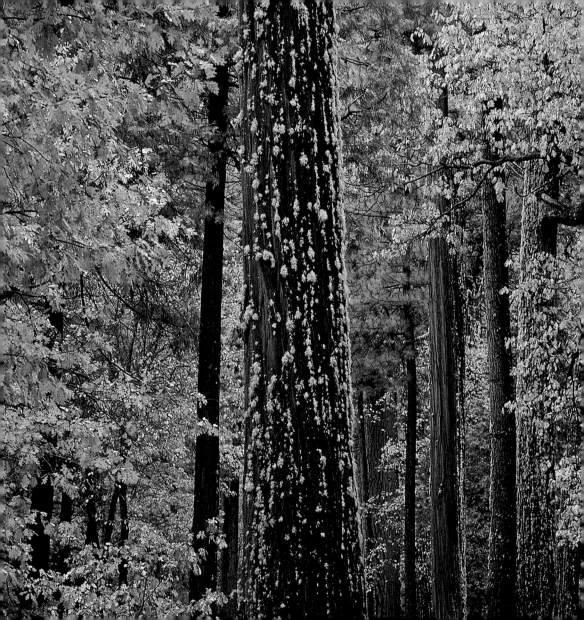

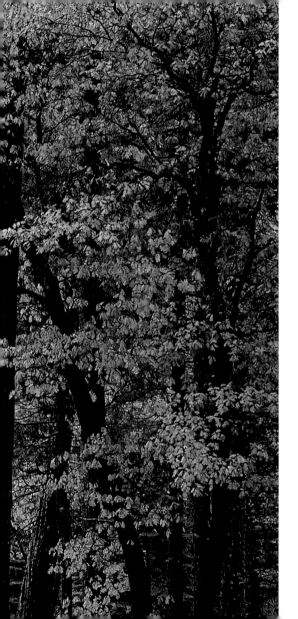

33

Mixed forest in fall
YOSEMITE VALLEY

A friend of mine
saw a bobcat

but I've never been that lucky.
Deer I've seen
and hawks, and a rattlesnake
and once an owl. It doesn't matter
which way you look

 up or down
there's always something there.

—LAWRENCE COLLINS

Bobcat in winter
YOSEMITE VALLEY

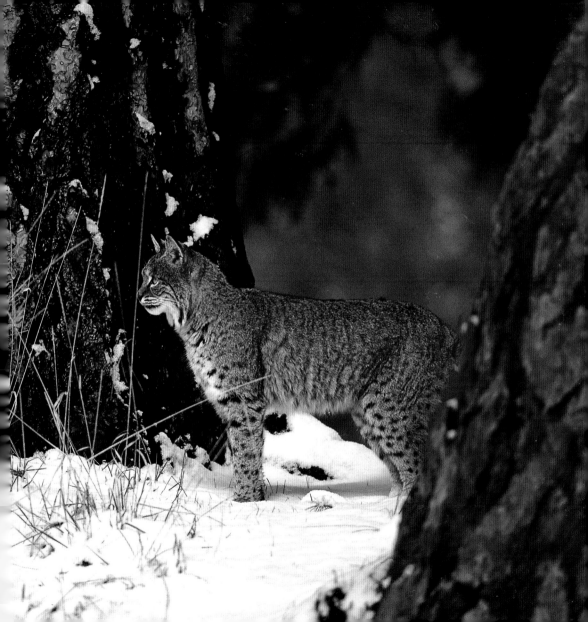

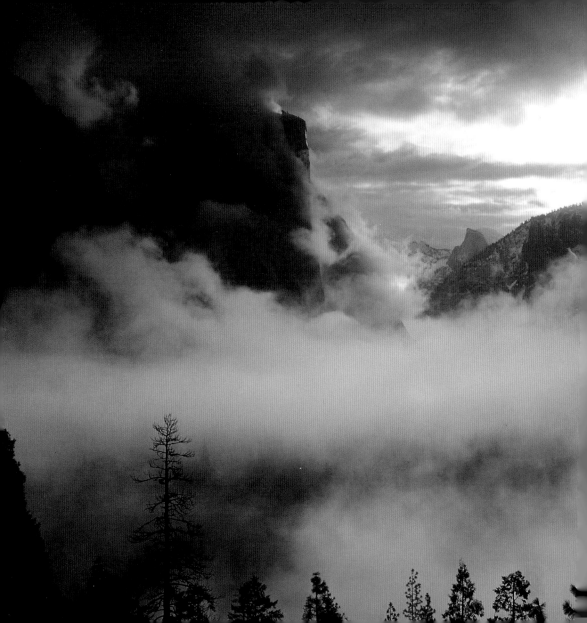

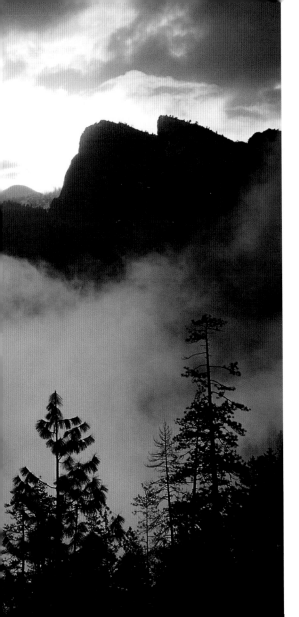

Winter sunrise
YOSEMITE VALLEY

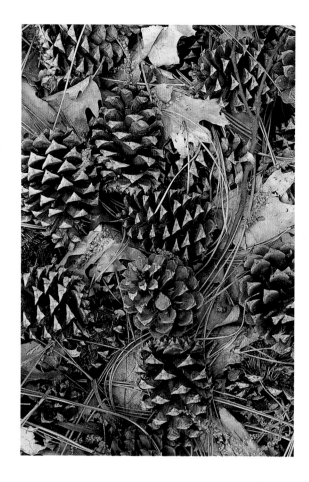

Pinecones on forest floor
YOSEMITE

Ferns and moss along cascade
in spring *(opposite)*
ABOVE YOSEMITE VALLEY

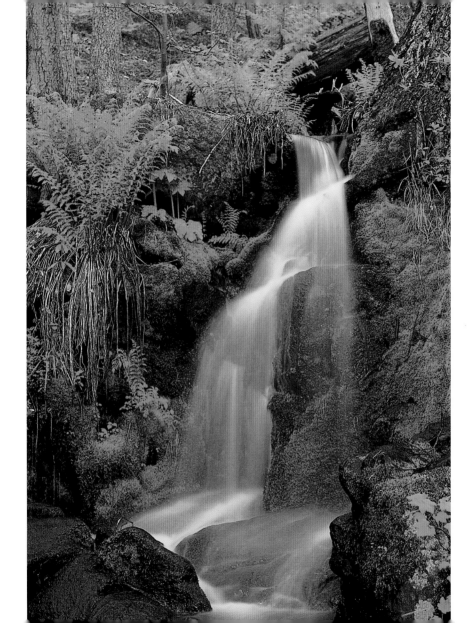

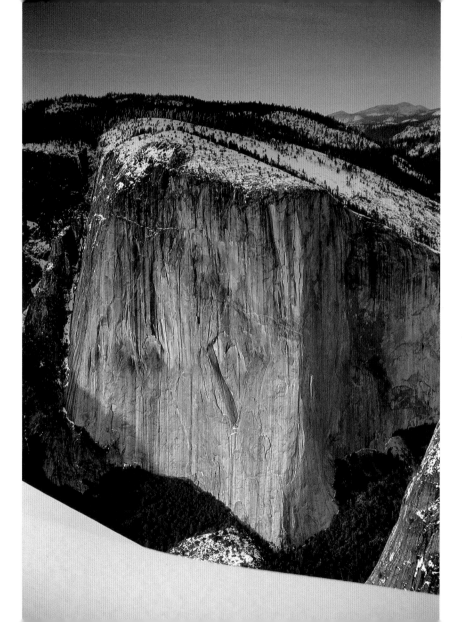

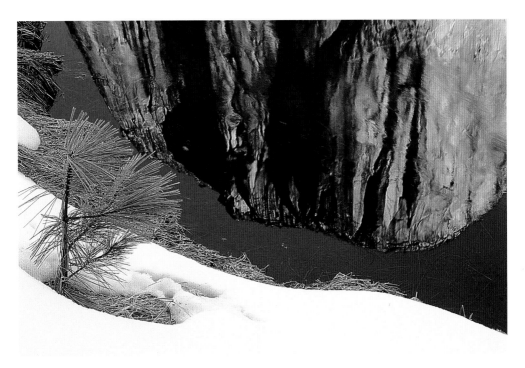

"Newborn" evergreen in winter with El Capitan reflected in Merced River
YOSEMITE

El Capitan in winter from Dewey Point *(opposite)*
YOSEMITE

I t is as if Nature had there put herself to show a parable of contrasted excellences, setting the stern heights and solemn silences of the cliffs against the soft demeanor and gentle voices of trees and flowers, streams and heavenly meadows; and to marry them together she pours the great waterfalls, in whose cloudy graces majesty and loveliness are so mingled that one cannot tell which of the two delights him the more.

—J. SMEATON CHASE

Moonset at sunrise over Basin Mountain
BUTTERMILK REGION, NEAR BISHOP
EASTERN SIERRA

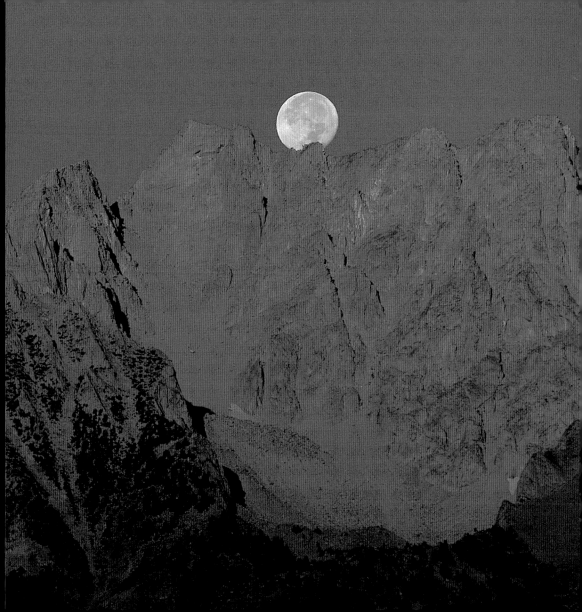

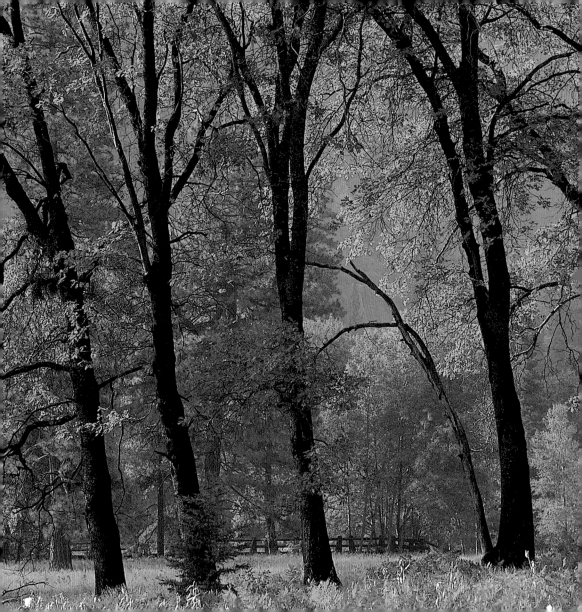

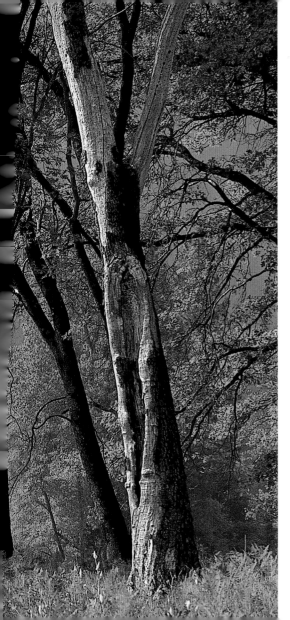

Look around you and see that the world of little things can be as beguiling as the large. First you learn the names of the waterfalls, then the granite. Soon you ask, "Is that a Ponderosa pine or a Jeffrey?" You want to know the names of the oaks, the birds, the flowers. Finally, even the smallest things become fascinating.

—CARL SHARSMITH

Oak trees in early fall
YOSEMITE VALLEY

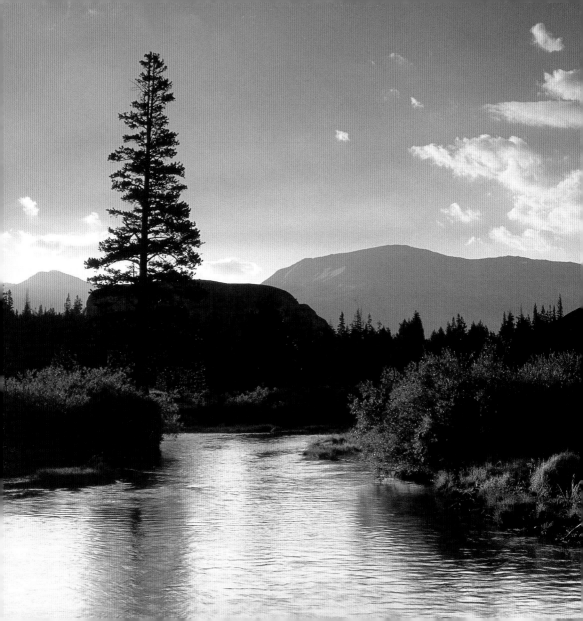

To trace the
history of a river, or a raindrop,
as John Muir would have done, 47
is also to trace the history of
the soul, the history of the
mind descending and arising in
the body. In both, we constantly
seek and stumble on divinity,
which, like the cornice feeding
the lake and the spring
becoming a waterfall, feeds,
spills, falls and feeds itself over
and over again.

—GRETEL ERHLICH

Morning light over the Tuolumne River
NEAR TUOLUMNE MEADOWS
YOSEMITE

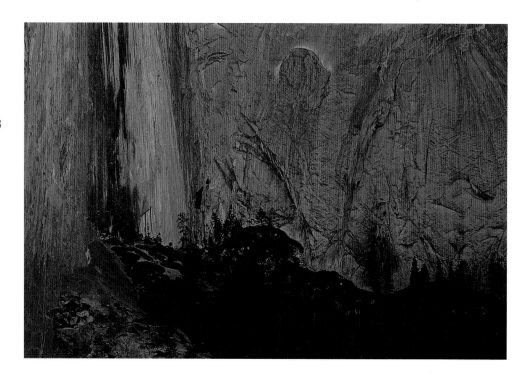

Sunset light on Half Dome from Glacier Point (detail)
YOSEMITE

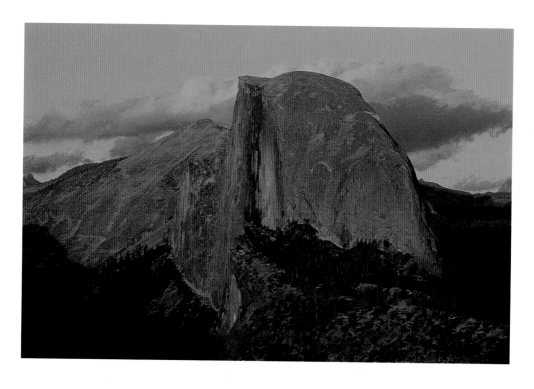

Half Dome and Clouds Rest from Glacier Point
YOSEMITE

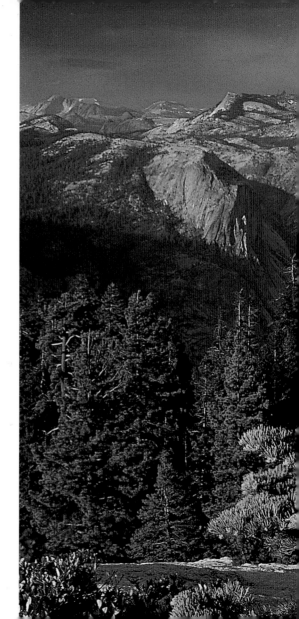

Light through storm clouds
on Half Dome from Sentinel Dome
YOSEMITE

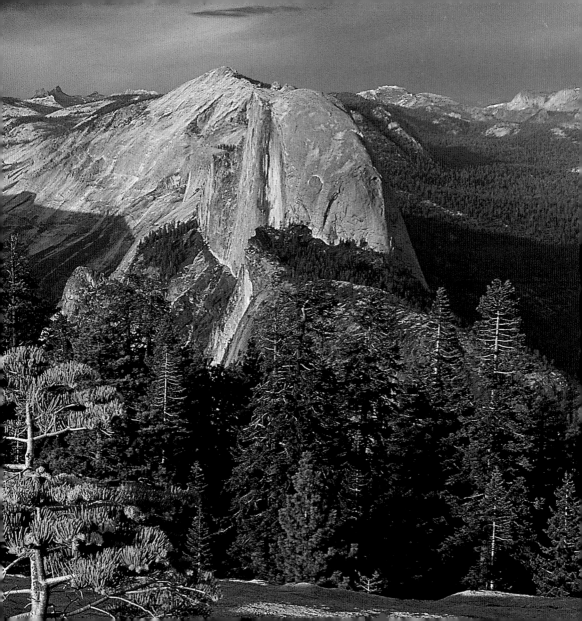

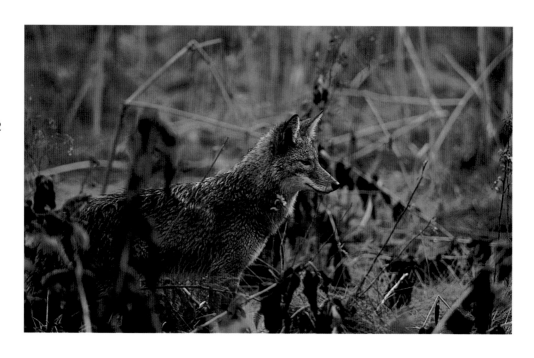

Coyote in Cooks Meadow
YOSEMITE VALLEY

Moonrise over "the teat," from 1000 Island Lake *(opposite)*
ANSEL ADAMS WILDERNESS, EASTERN SIERRA

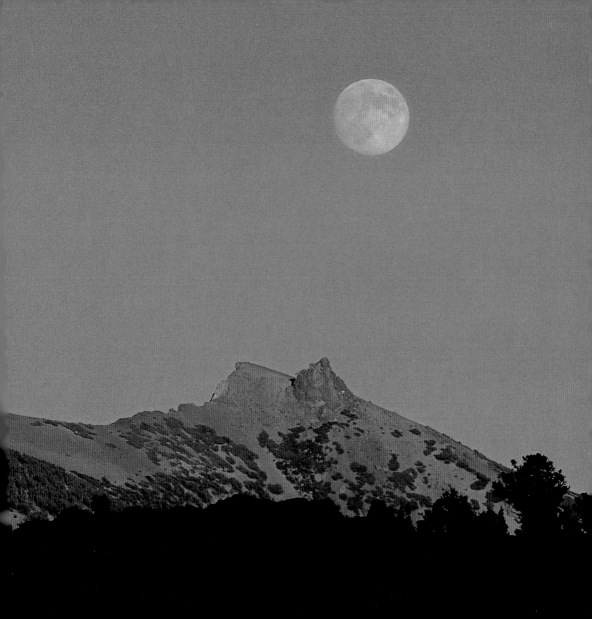

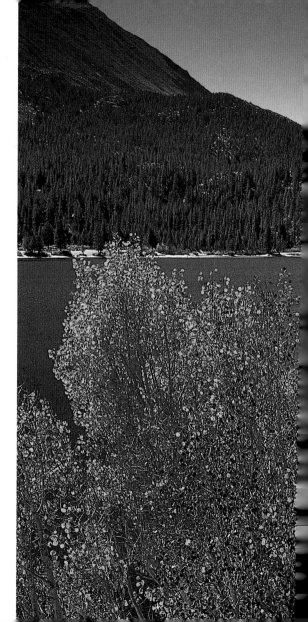

The water was so clear and calm I could see the

reflection of a granite cliff that towered almost a mile above us. An otter swam noiselessly near shore. A kingfisher dived from an overhanging branch. Somewhere far up the canyon wall an eagle screeched. All else was quiet.

—WILLIAM O. DOUGLAS

Fall colors on aspen trees
at Rock Creek Lake
ROCK CREEK CANYON
EASTERN SIERRA

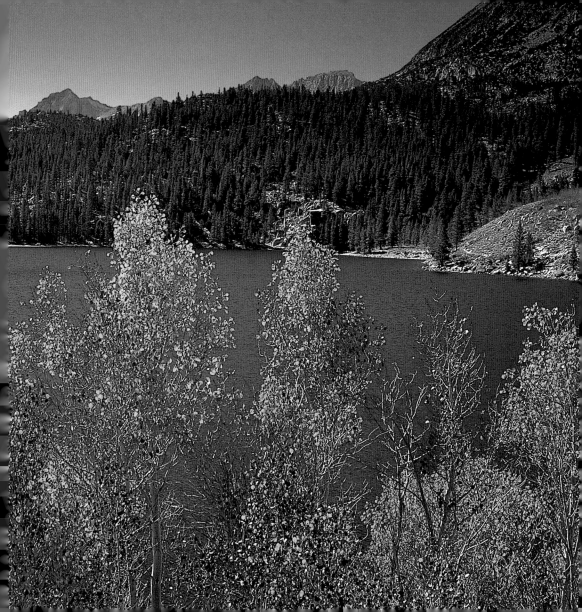

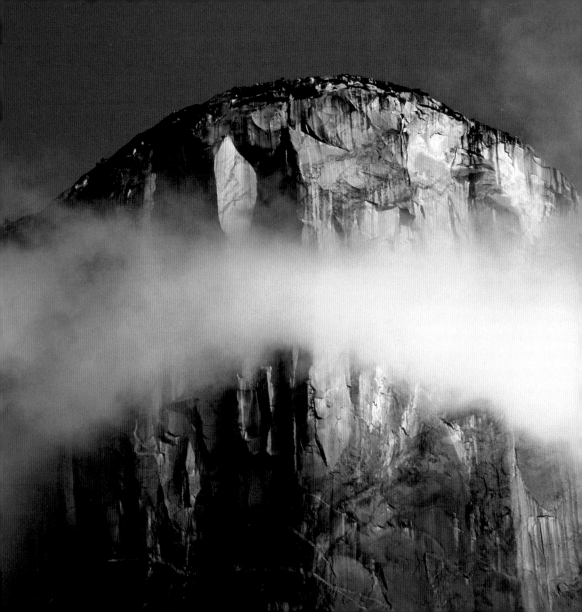

The air up
there in the clouds is very pure
and fine, bracing and delicious.
And why shouldn't it be? —it
is the same the angels breathe.

—MARK TWAIN

Order and chaos converge
near the summit of El Capitan
YOSEMITE

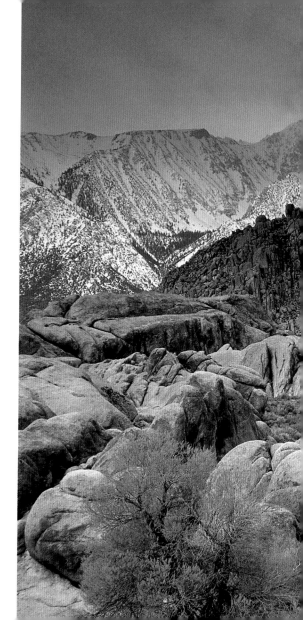

Spring snowstorm over Lone Pine Peak
ABOVE ALABAMA HILLS
NEAR LONE PINE, EASTERN SIERRA

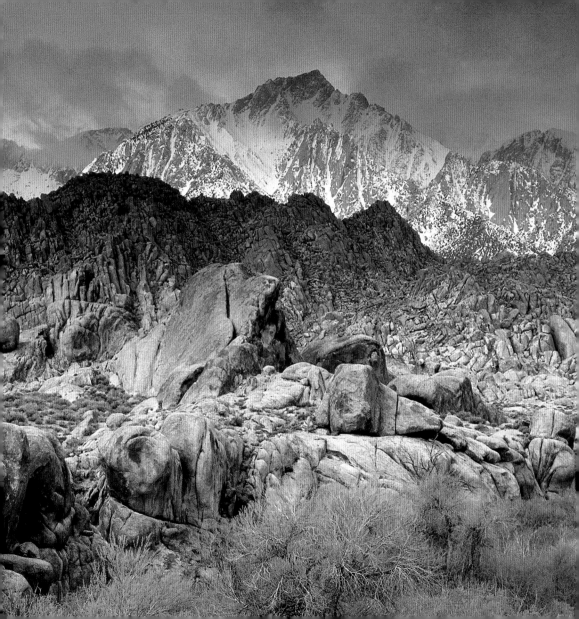

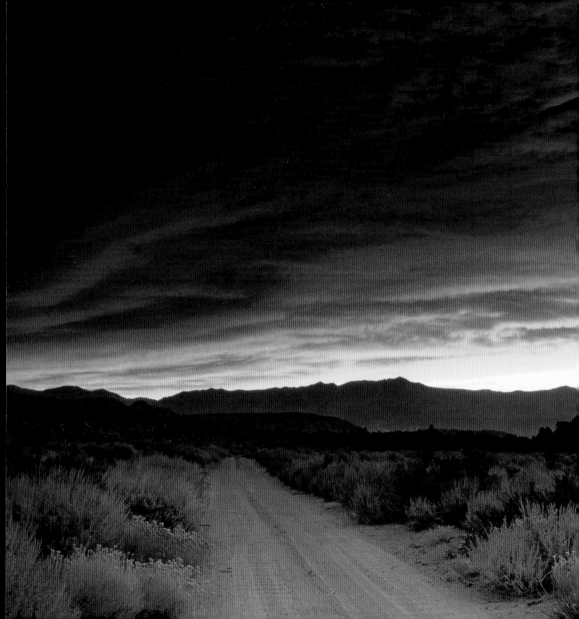

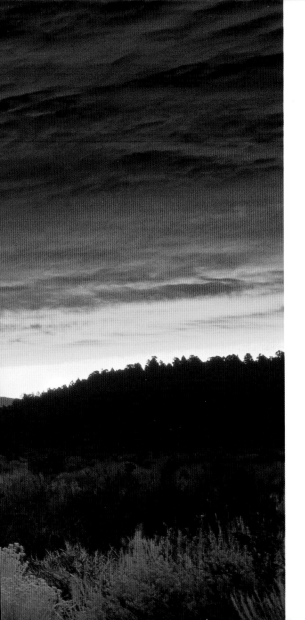

Take a course in good water and air, and in the eternal youth of Nature you may renew your own. Go quietly; alone; no harm will befall you.

—JOHN MUIR

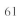 61

Sunrise over dirt road near Bishop
EASTERN SIERRA

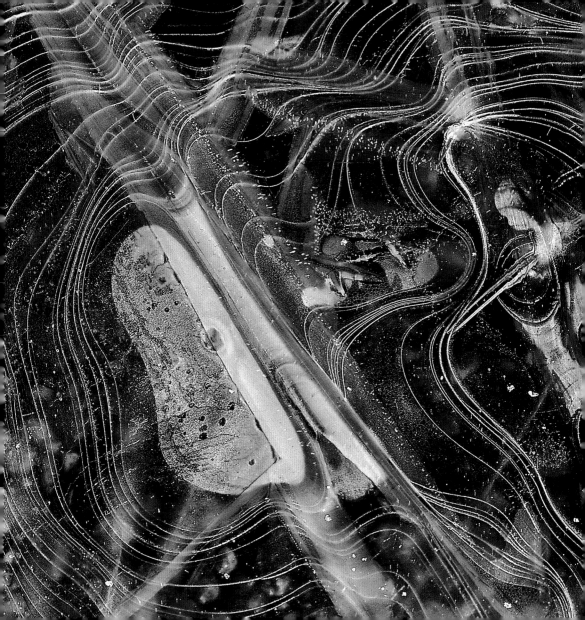

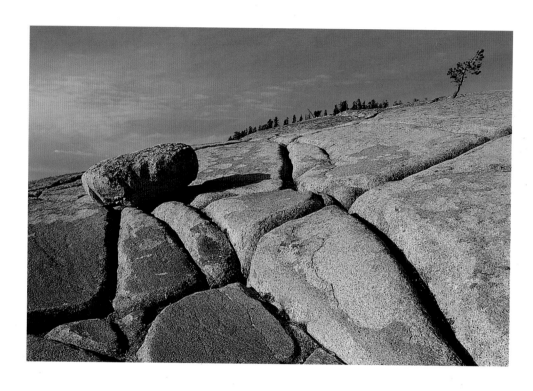

Glacial erratic at Olmsted Point
YOSEMITE

Ice pattern in the Merced River (*opposite*)
YOSEMITE

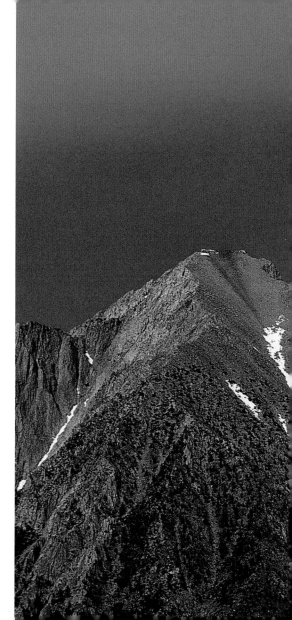

The grand show is eternal. It is always sunrise somewhere; the dew is never dried all at once; a shower is forever falling; vapor is ever rising. Eternal sunrise, eternal dawn and gloaming, on sea and continents and islands, each in its turn, as the round earth rolls.

—JOHN MUIR

Moonset over the crest of the
Eastern Sierra near Independence
INYO COUNTY, EASTERN SIERRA

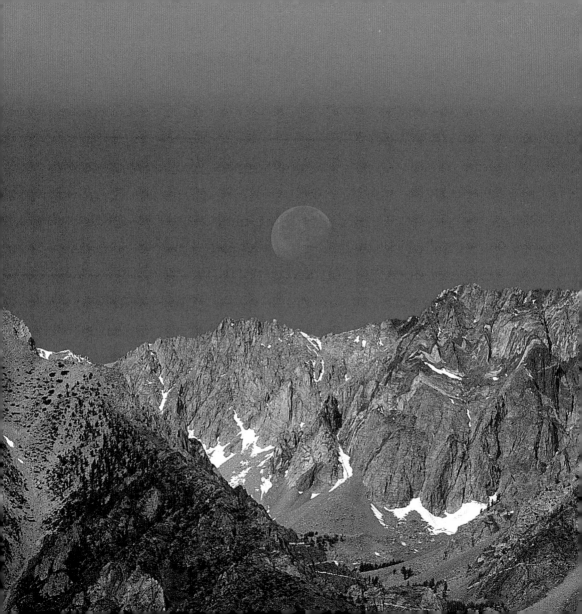

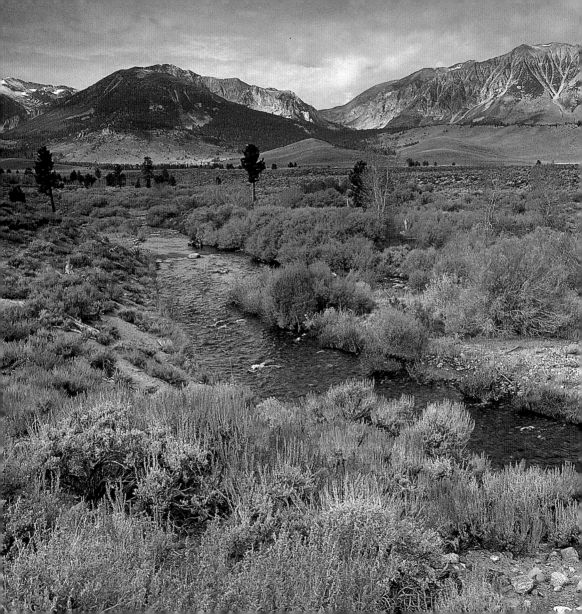

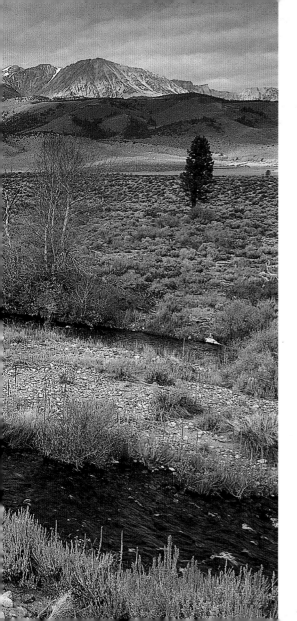

The streambeds, I knew, were surfaces of life. They spoke to me, as did the great mountains and towering trees that cycled and used the waters around me. From streams and forests and mountains I felt excitement, beauty, inspiration.

—TOM HAYDEN

Fall colors along Eastern Sierra crest
NEAR LEE VINING AND MONO LAKE
EASTERN SIERRA

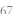

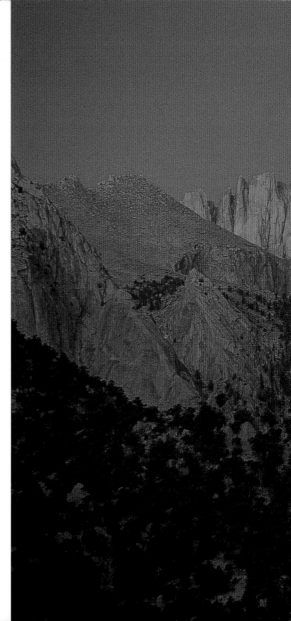

Now and then nature produces a combination of land, water, sky, space, trees, animals, flowers, distances, and weather so perfect it looks like the hatching of a romantic fantasy. . . every time we go off into the wilderness, we are looking for that perfect primitive Eden.

—WALLACE STEGNER

Predawn glow on Mount Whitney and Keeler Needle from Whitney Portal
NEAR LONE PINE, EASTERN SIERRA

Merced River in spring (*overleaf*)
YOSEMITE VALLEY

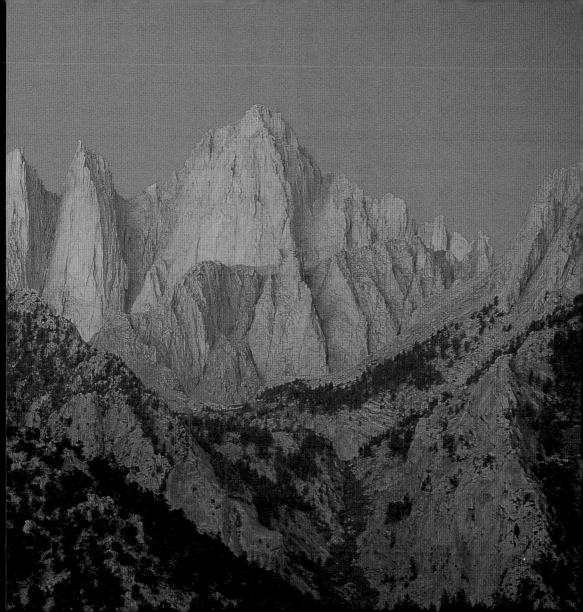

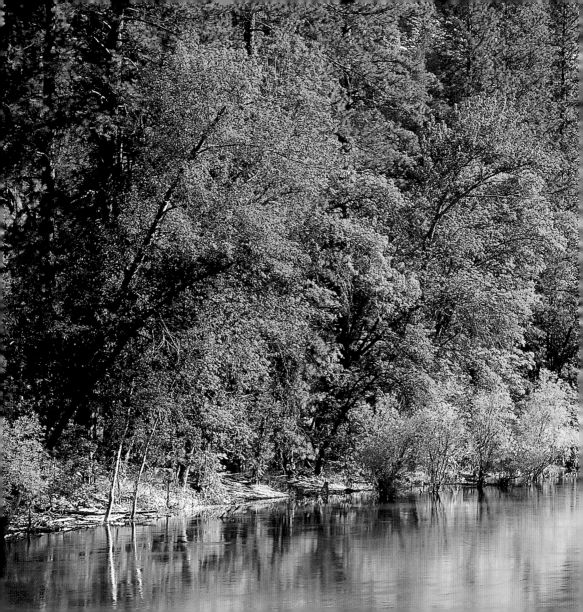

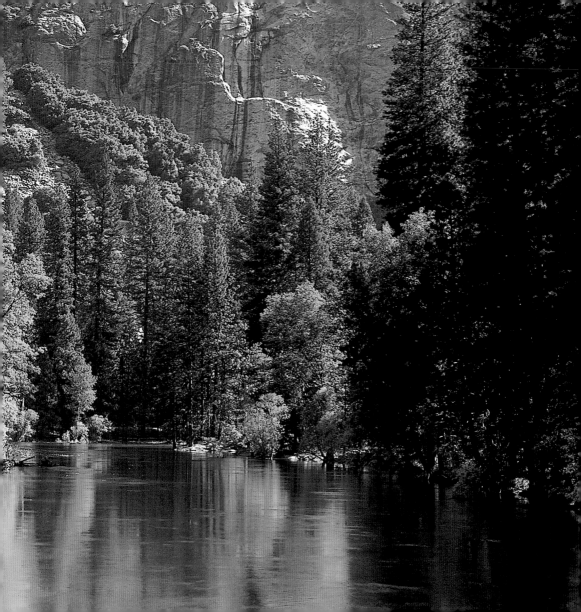

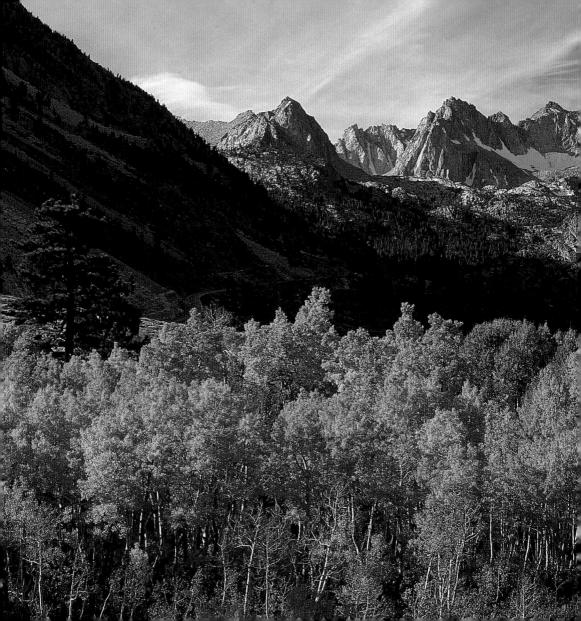

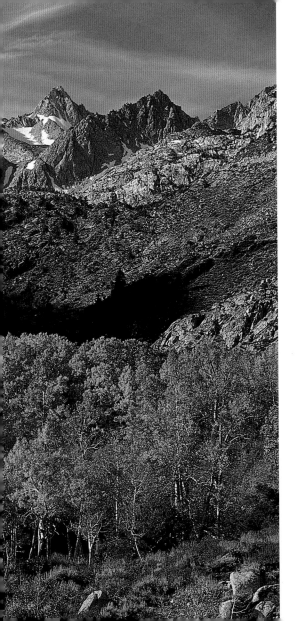

Once in a lifetime, perhaps, one escapes the actual confines of the flesh. Once in a lifetime, if one is lucky one so merges with sunlight and air running water that whole eons, the eons that mountains and deserts know, might pass in a single after-noon without discomfort.

—LOREN EISELEY

Aspens in fall below the High Sierra
NEAR BISHOP, EASTERN SIERRA

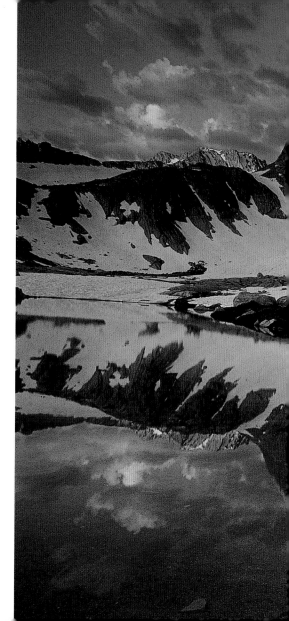

When we contemplate the whole globe as one great dewdrop, striped and dotted with continents and islands, flying through space with all other stars all singing and shining together as one, the whole universe appears as an infinite storm of beauty.

—JOHN MUIR

Sunrise light on North Peak
20 Lakes Basin
EASTERN SIERRA

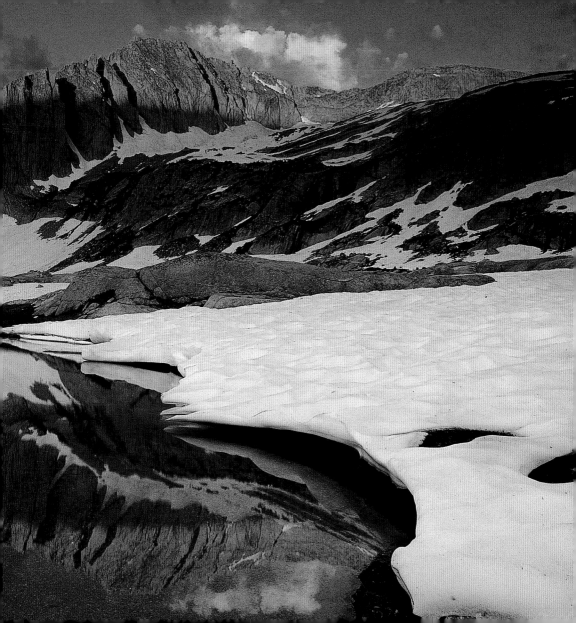

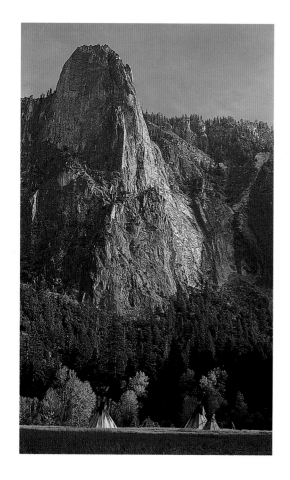

Native American tepees
below Sentinel Rock
YOSEMITE

Rainbow in Upper Yosemite Fall
YOSEMITE

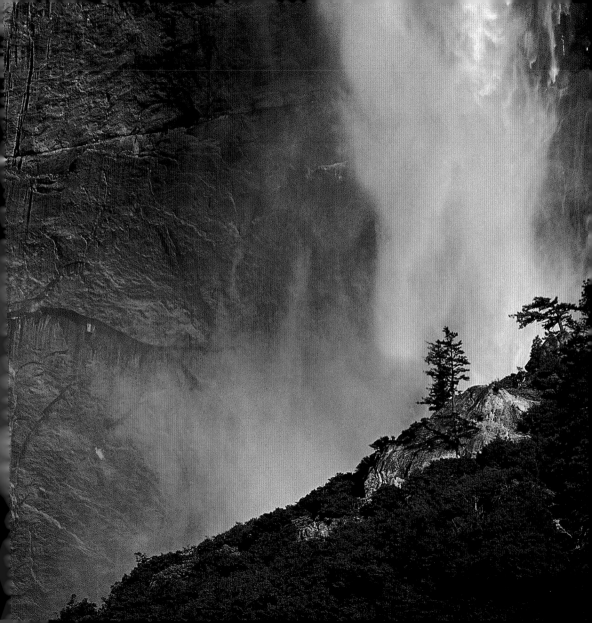

Arched Rock in Alabama Hills
NEAR LONE PINE, INYO COUNTY

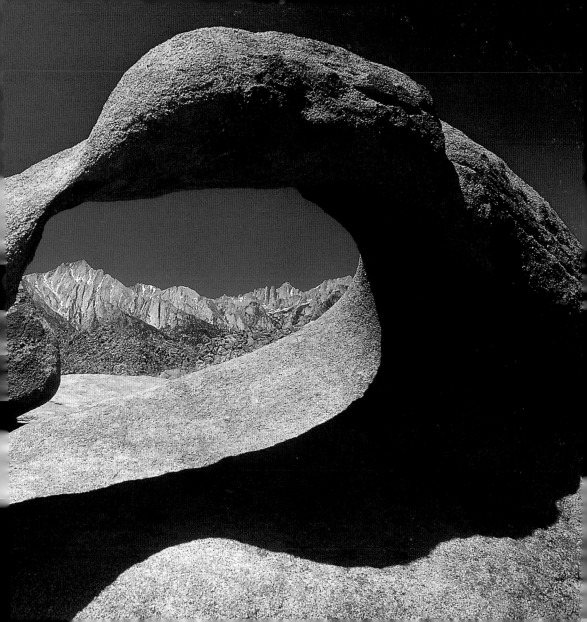

The Sierra has the brightest weather, brightest glacier-polished rocks, the greatest abundance of irised spray from its glorious waterfalls, the brightest forests of silver firs and silver pines, more starshine, moonshine, and perhaps more crystalshine than any other mountain chain, and its countless mirror lakes, having more light poured into them, glow and spangle most. And how glorious the shining after the short summer showers and after frosty nights when the morning sunbeams are pouring through the crystals on the grass and pine needles, and how ineffably spiritually fine is the morning-glow on the mountain-glow on the mountain-tops and the alpen-glow of evening. Well may the Sierra be named, not the Snowy Range, but the Range of Light.

—JOHN MUIR

Sunrise on Mount Humphreys
BUTTERMILK AREA
NEAR BISHOP, EASTERN SIERRA

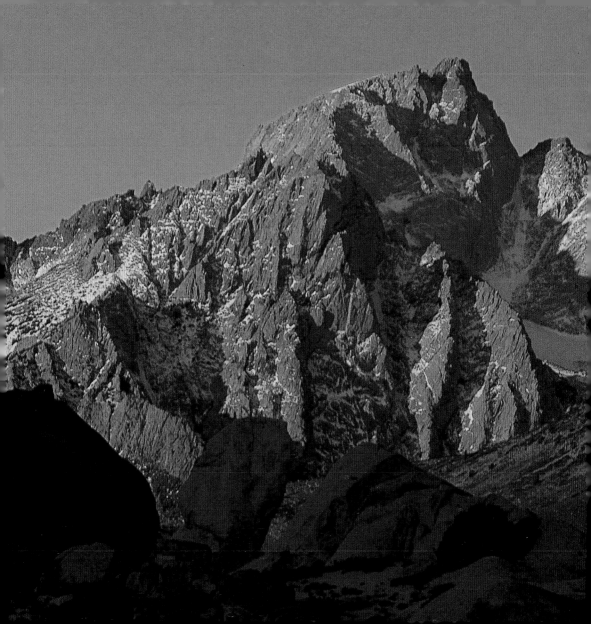

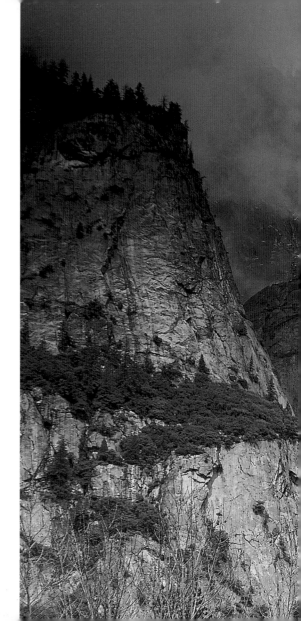

I ts many
waterfalls fluttering like white
lace against its vertical granite
walls, its smooth level floor,
its noble pines and oaks, its
open glades, its sheltering
groves, its bright clear winding
river, its soft voice of many
waters, its flowers, its birds, its
grass…all enclosed in this
tremendous granite frame—
what an unforgettable picture it
all makes.

—JOHN BURROUGHS

Upper Yosemite Fall
during a spring rain storm
YOSEMITE VALLEY

82

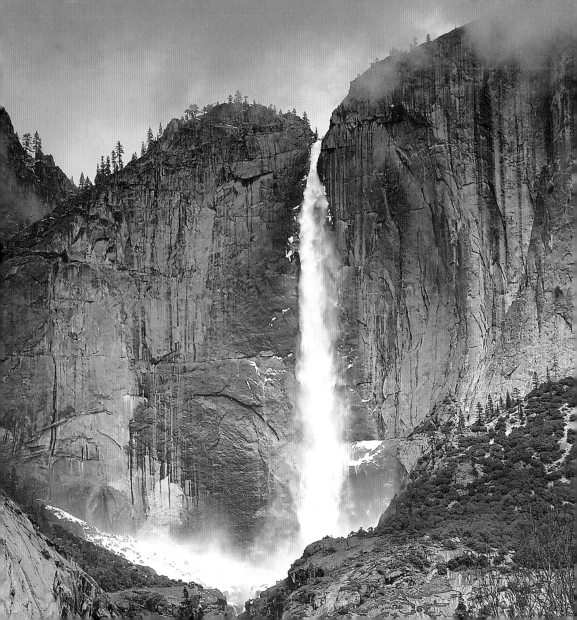

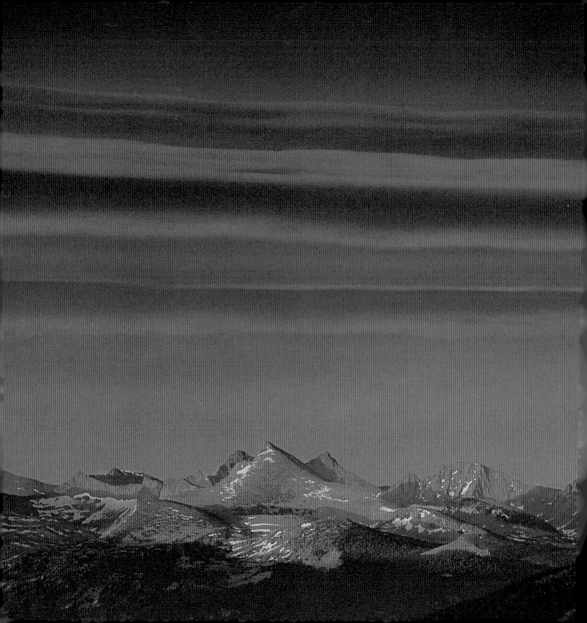

A land of
contrast and incredible
intensity, where the sky is the
size of forever and the flowers
the size of a millisecond.

—ANN ZWINGER

85

Alpenglow at sunset on clouds
above the Sierra crest from atop
Sentinel Dome
YOSEMITE

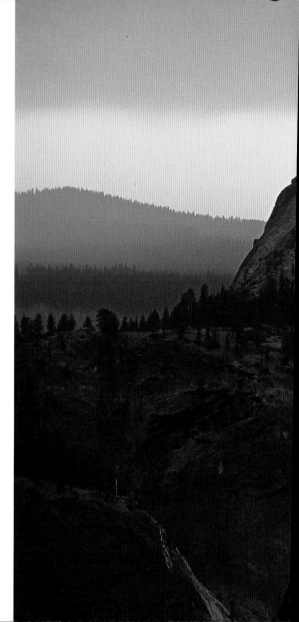

Sunset light on the face of
Half Dome from Olmsted Point
TIOGA PASS ROAD, YOSEMITE

Sunset over Tenaya Peak and
Tenaya Lake *(overleaf)*
TIOGA PASS ROAD, YOSEMITE

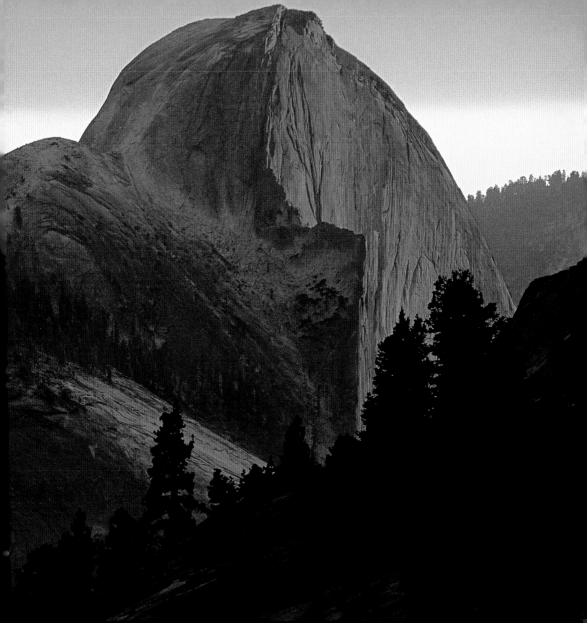

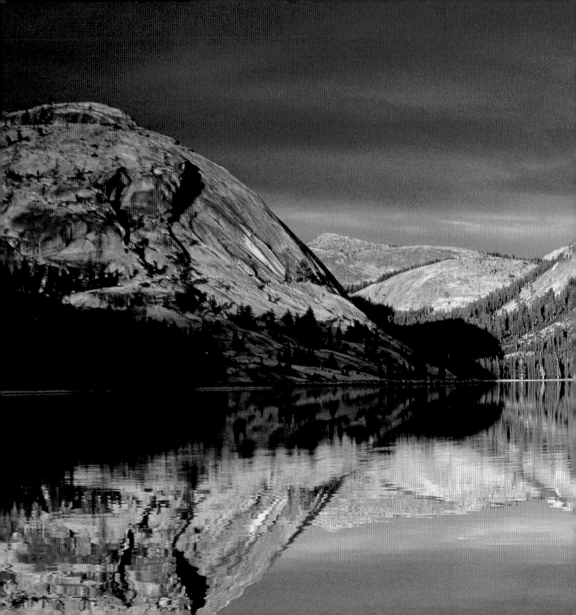

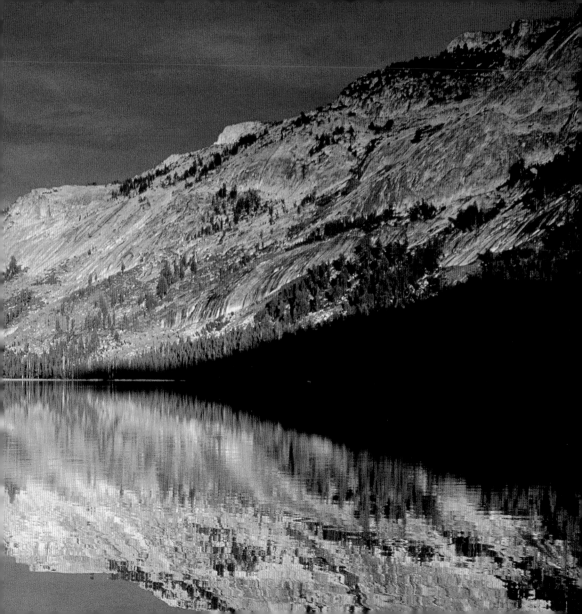

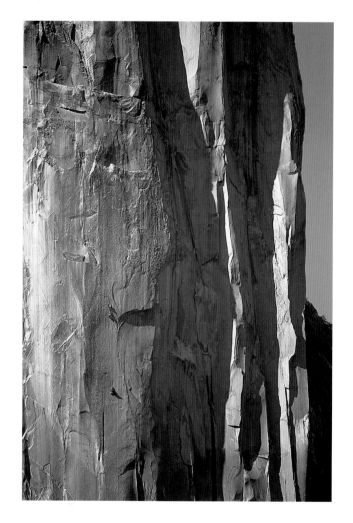

Climbers on the Salathe Wall, El Capitan
YOSEMITE VALLEY

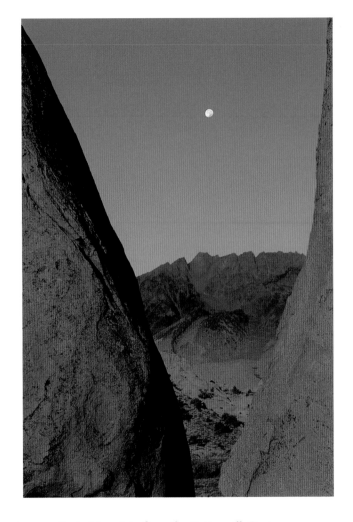

Moonset at sunrise over Basin Mountain from the Buttermilk Region
NEAR BISHOP, EASTERN SIERRA

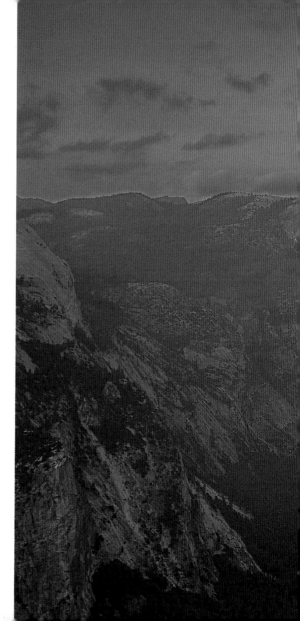

One should
sleep on the brink of that
Valley, dream of it all night,
and drop down into it on the
wings of morning.

—CHARLES WARREN STODDARD

Sunset light on clouds above
Half Dome and Tenaya Canyon
from Glacier Point
YOSEMITE

Alpenglow on storm clouds
at sunrise *(overleaf)*
EASTERN SIERRA

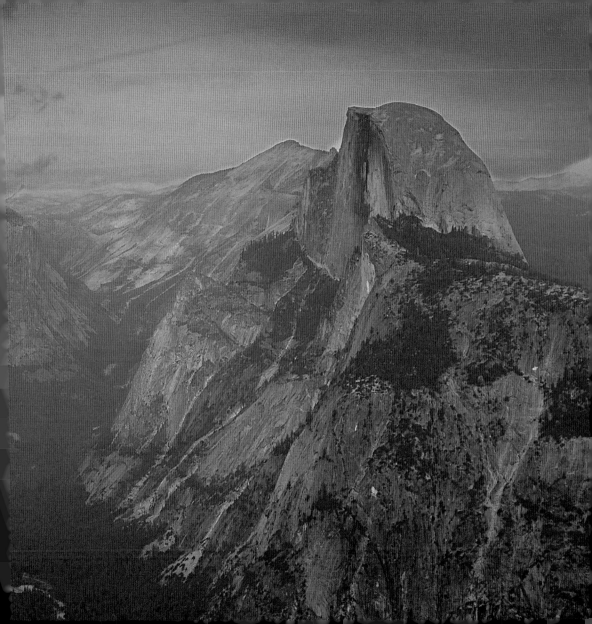

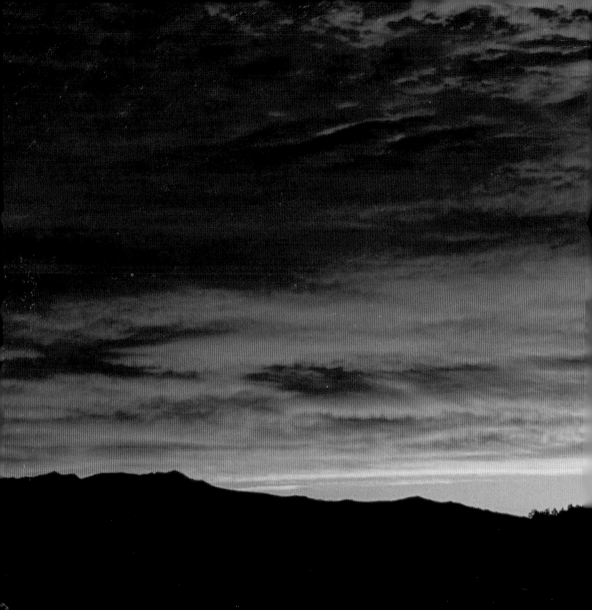

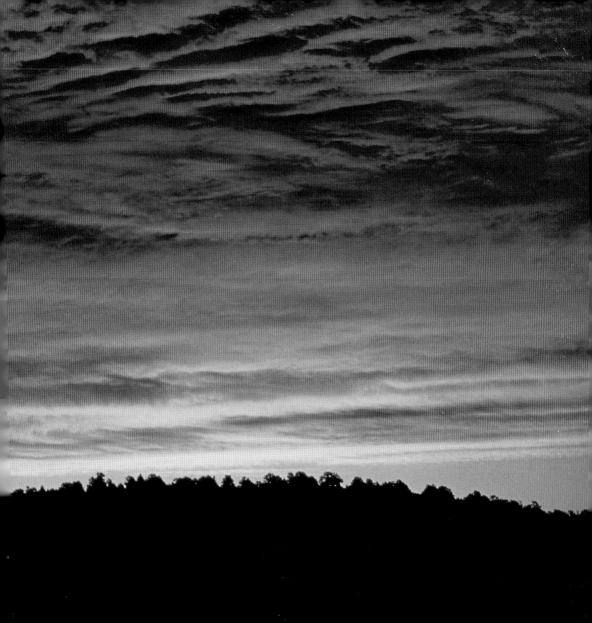

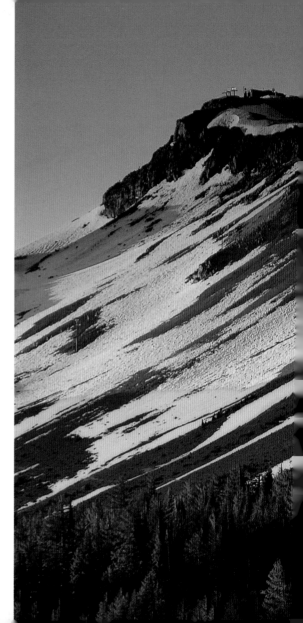

That scene of unequaled grandeur and beauty is forever stamped on my memory, to remain when all other scenes of earth have passed from remembrance. . . the bright white water dashing over the distant gray tops seen against the dark blue of the unfathomable sky…the winding stream, and peaceful greensward with gay wild-flowers below, the snowy summits…the atmosphere of glory illuminating all, and the eternal voice of many waters wherever you walk or rest!

—CHARLES LORING BRACE

**Sunrise over Mammoth Peak
from Minaret Summit**
MONO COUNTY, EASTERN SIERRA

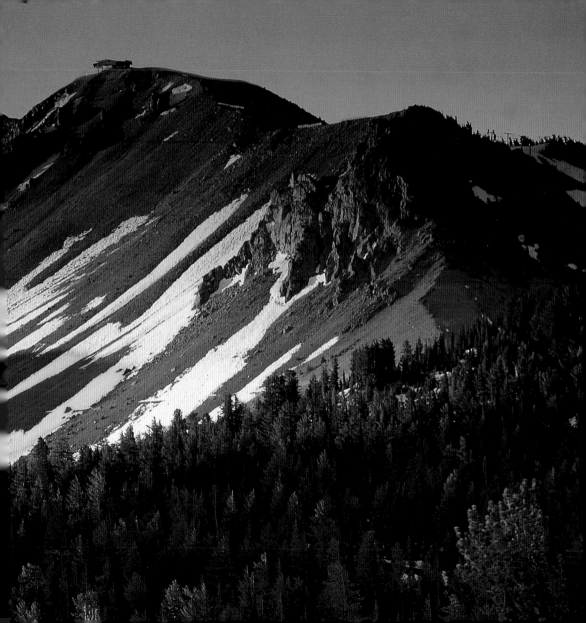

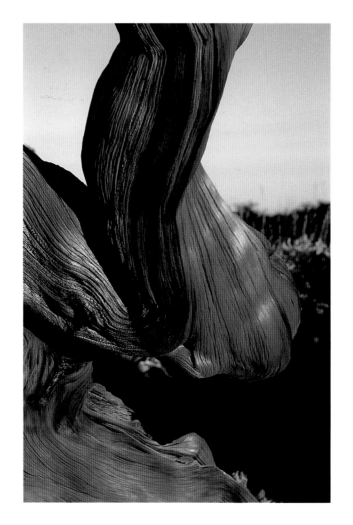

Bristlecone Pine
ANCIENT BRISTLECONE FOREST, WHITE MOUNTAINS

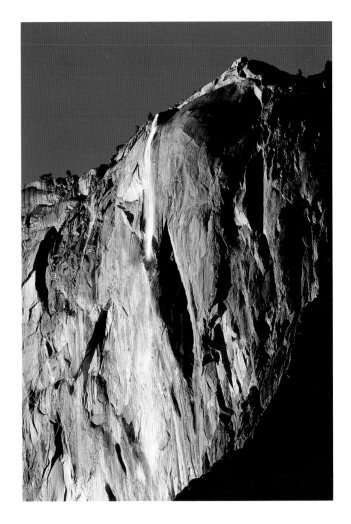

Horsetail Falls
YOSEMITE VALLEY

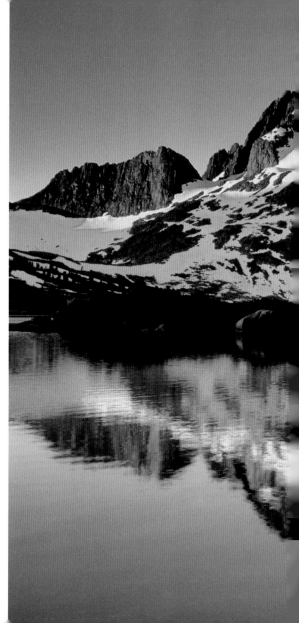

W hoever climbs to the summits of the Sierra will know why prophets have always sought mountain-tops to commune with their gods. A strong, clear light falls on a frozen tableau: massive rock on massive rock with scattered lakelets to interrupt the vast cold emptiness.

—EZRA BOWEN

100

Alpenglow at sunrise;
Banner Peak over 1000 Island Lake
ANSEL ADAMS WILDERNESS
EASTERN SIERRA

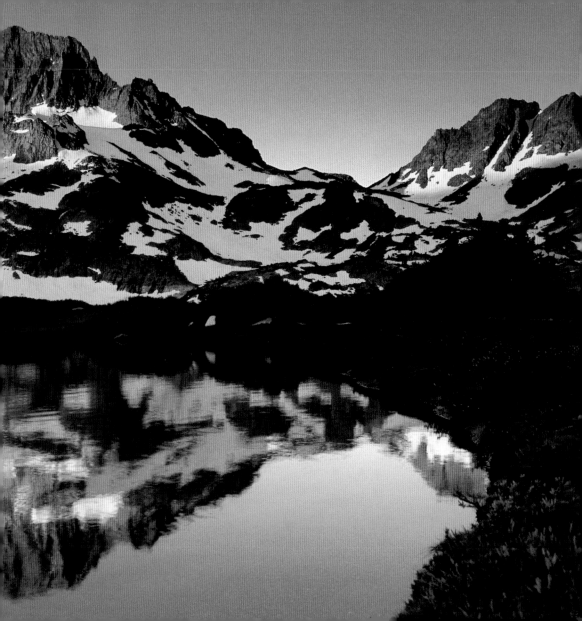

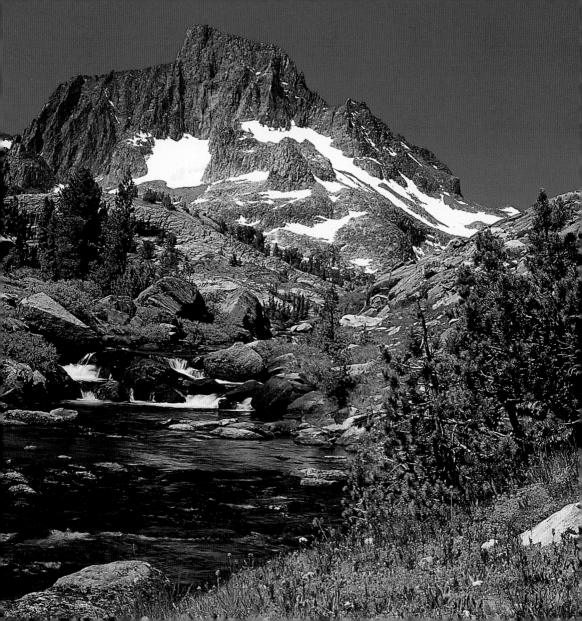

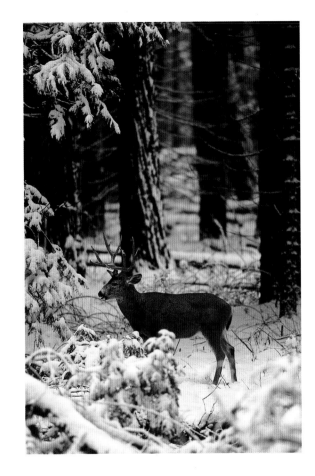

Deer in winter
YOSEMITE VALLEY

Wildflowers below
Banner Peak *(opposite)*
ANSEL ADAMS WILDERNESS
EASTERN SIERRA

Full moon rises next to
Mount Clark at sunset *(overleaf)*
YOSEMITE

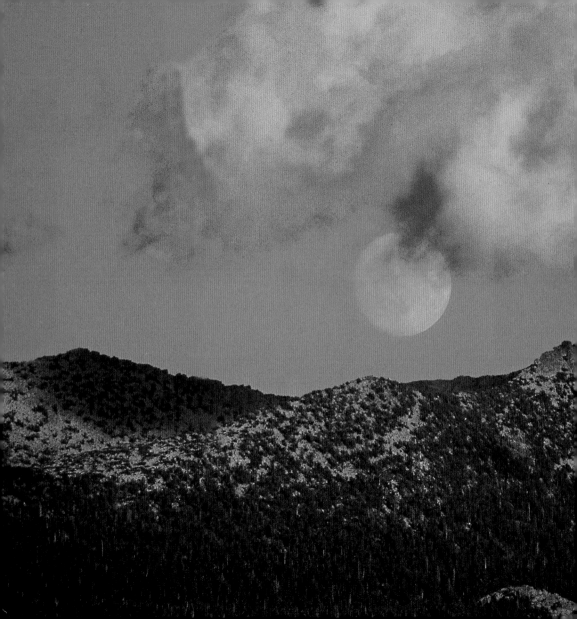

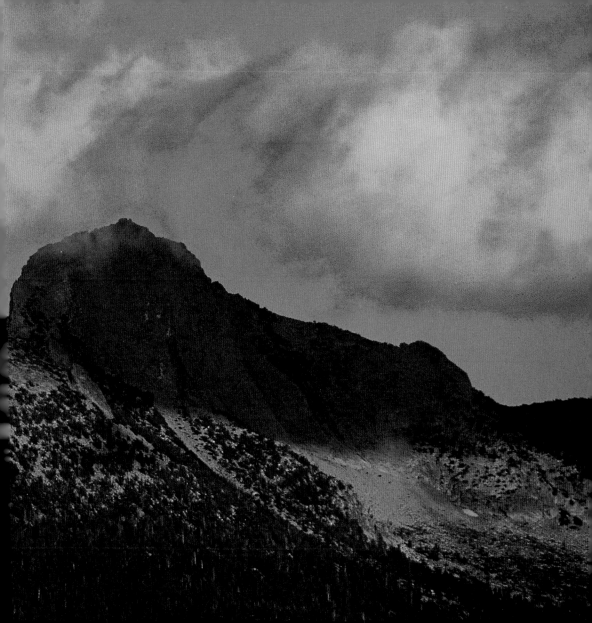

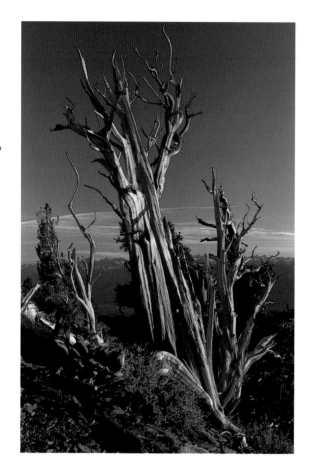

Bristlecone Pine at sunset
looking toward the Sierra
ANCIENT BRISTLECONE PINE FOREST
WHITE MOUNTAINS

Fall colors in sunlight on ridge along
the South Fork of Bishop Creek
(opposite)
EASTERN SIERRA

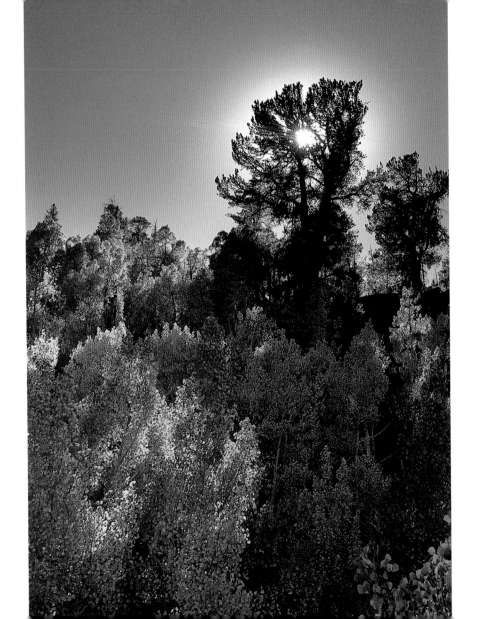

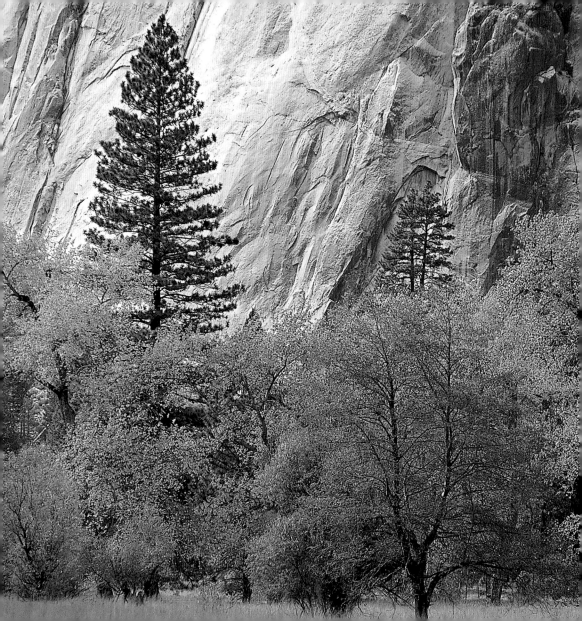

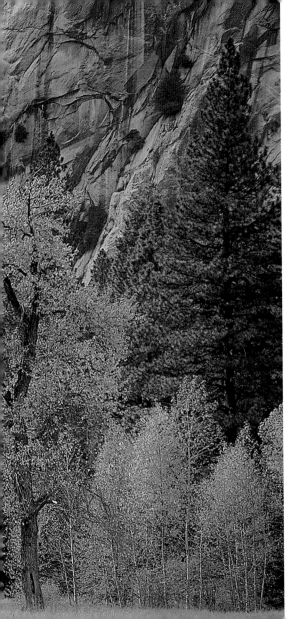

Then I walked
down to the ledge and crawled
out upon the overhanging
rocks. In all my life I think
I shall see nothing else so
grand, so sublime, so
beautiful—beauty of a beauty
not of this earth—as that
vision of the Valley.

—THEODORE BUNNELL

Aspen, oak, and pine trees
below granite cliff
YOSEMITE VALLEY

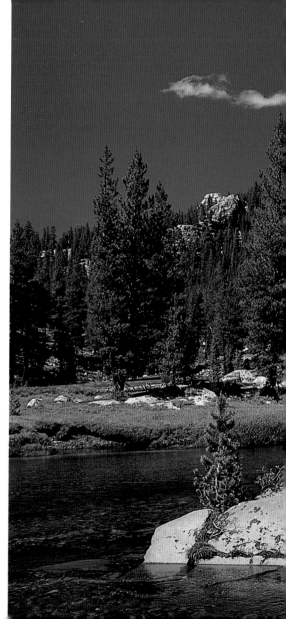

Neck craned upward, to the summit of Clouds Rest; arms spread outward, describing the sweep of the Merced as it courses through the valley; heart and soul racing in tandem to comprehend all that they see, all that they bring to the act of seeing, in this place where sky, sun, rock, rain—and time— make one wonder while making wonder one's purest response.

—JONATHON KING

Tuolumne River in summer
TUOLUMNE MEADOWS
NEAR TIOGA PASS ROAD, YOSEMITE

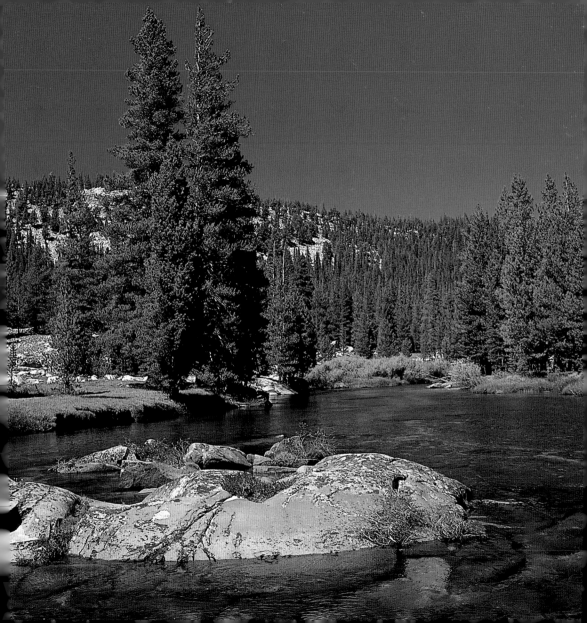

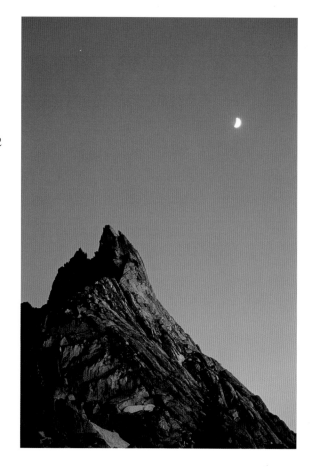

Crescent moon and Venus
in the evening over Ragged Peak
TUOLUMNE REGION, YOSEMITE

Jeffrey Pine atop
Sentinel Dome *(opposite)*
YOSEMITE

Columnar basalt rock formation
at Devils Postpile National
Monument *(overleaf)*
EASTERN SIERRA

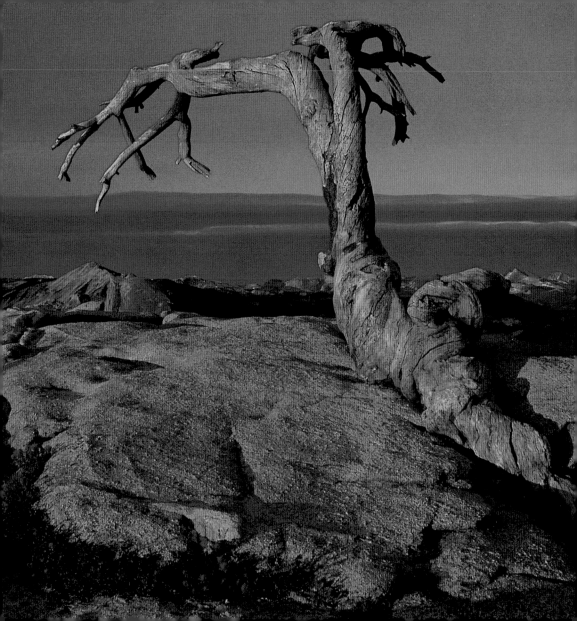

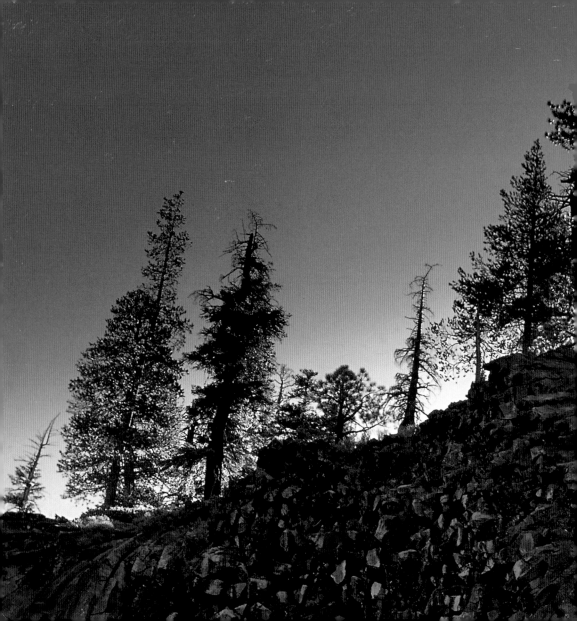

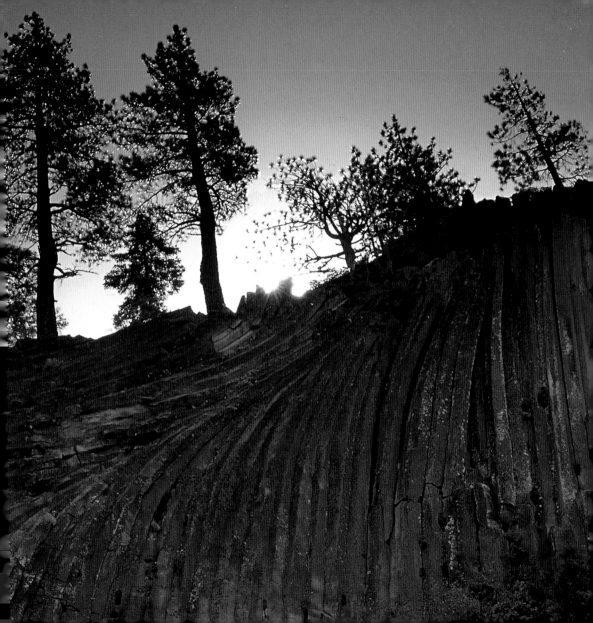

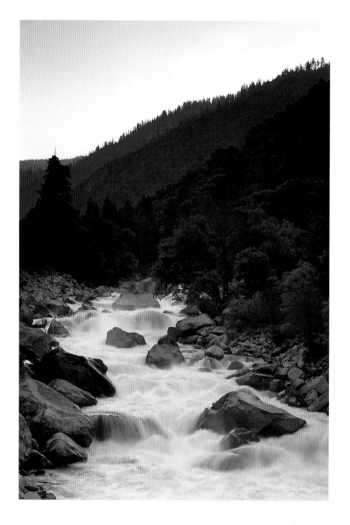

Merced River Canyon in spring
YOSEMITE

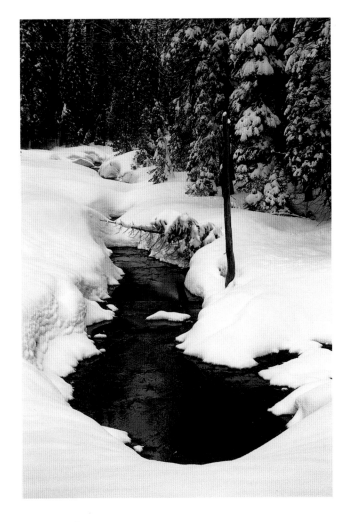

Winter stream near Crane Flat
YOSEMITE

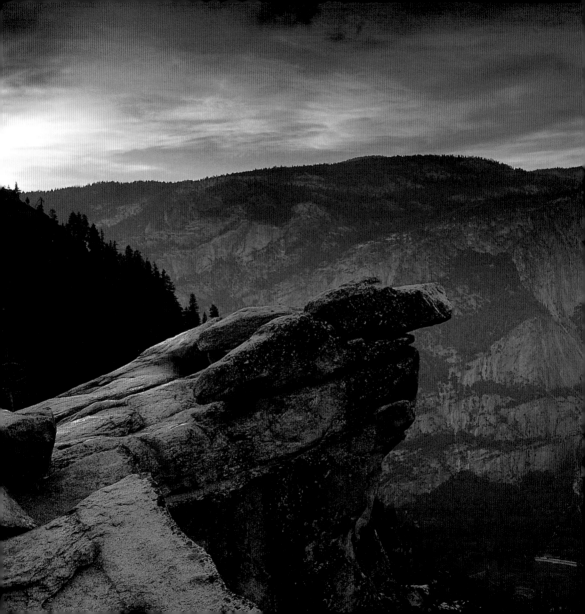

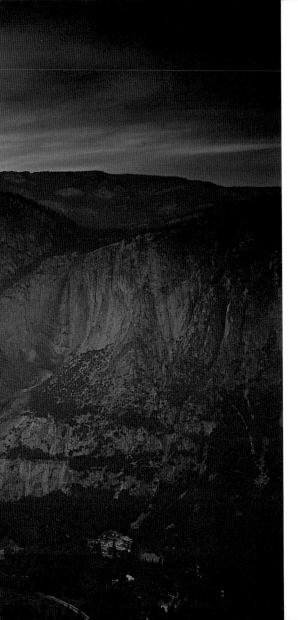

Sunset light on clouds above
Yosemite Valley from Glacier Point
YOSEMITE

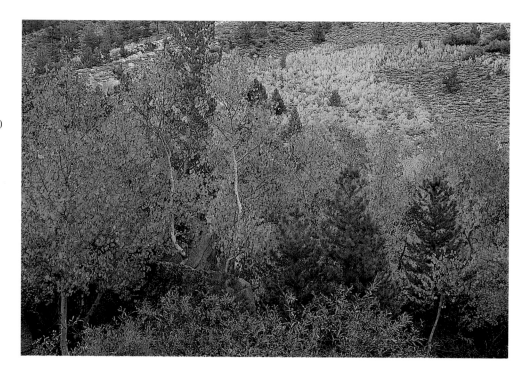

Pastel colors in fall along the Middle Fork of Bishop Creek
EASTERN SIERRA

Dogwoods in bloom *(opposite)*
YOSEMITE VALLEY

Winter storm clouds shroud El Capitan at sunrise *(overleaf)*
YOSEMITE

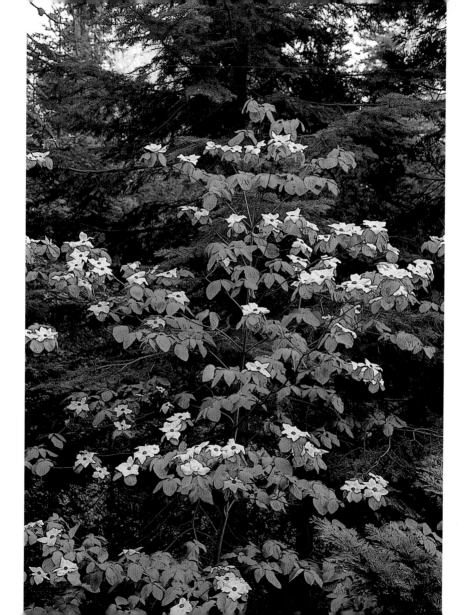

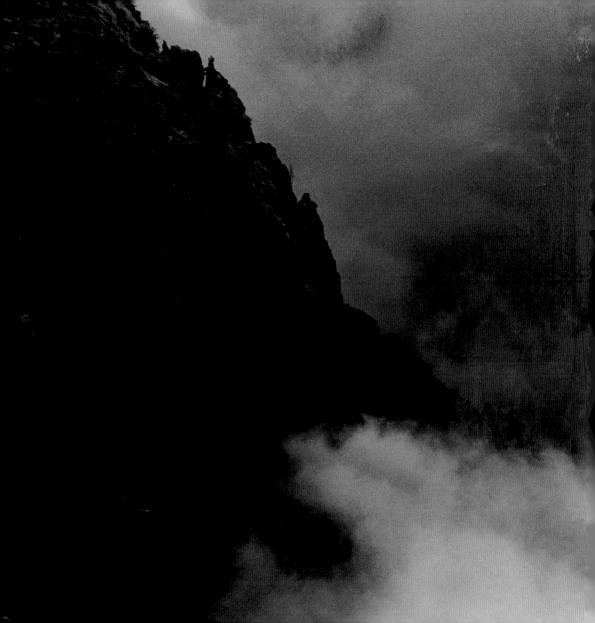

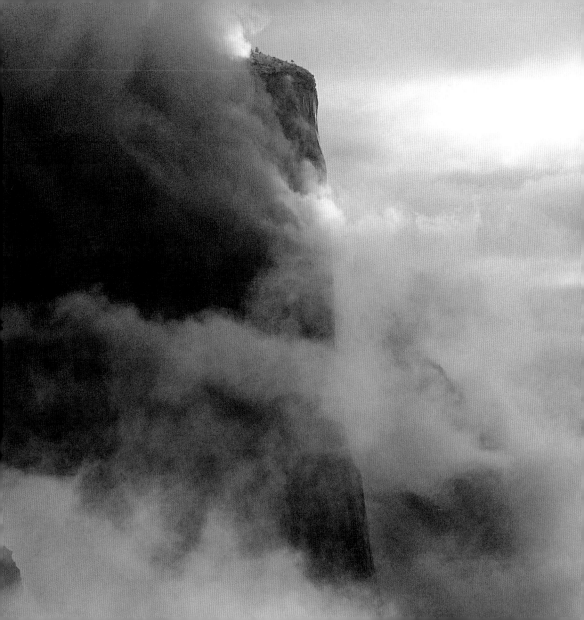

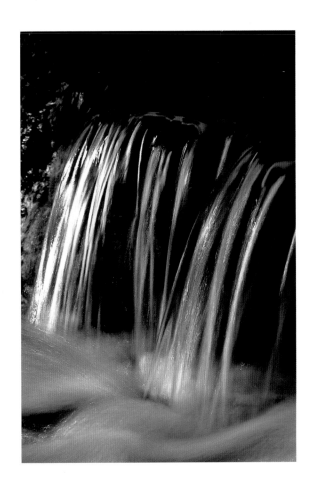

Fern Spring
in morning light
YOSEMITE VALLEY

Storm clouds
over Nevada Falls
and Little Yosemite Valley
(*opposite*)
YOSEMITE VALLEY

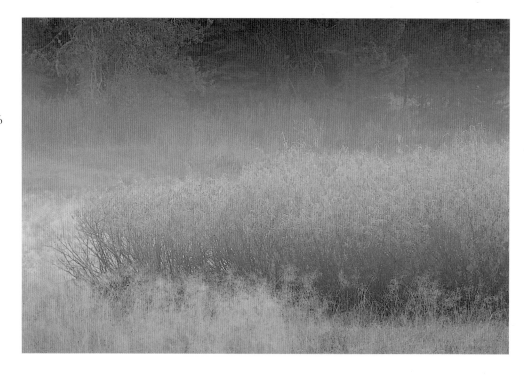

Misty fall morning
CRANE FLAT, YOSEMITE

Olmsted Point *(opposite)*
TIOGA PASS ROAD, YOSEMITE

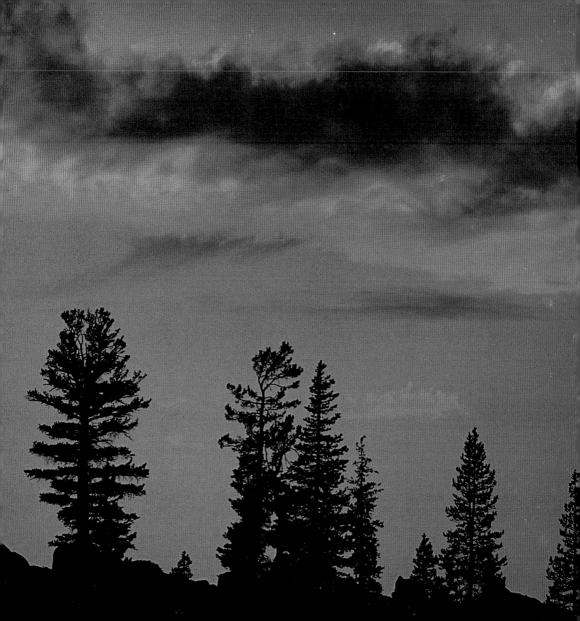

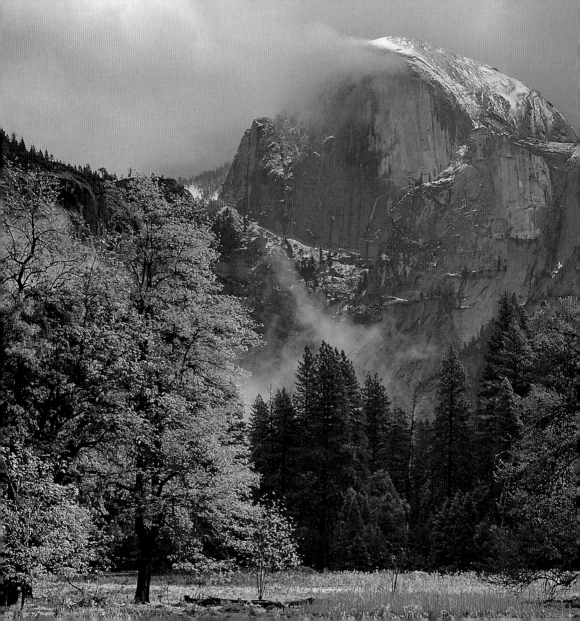

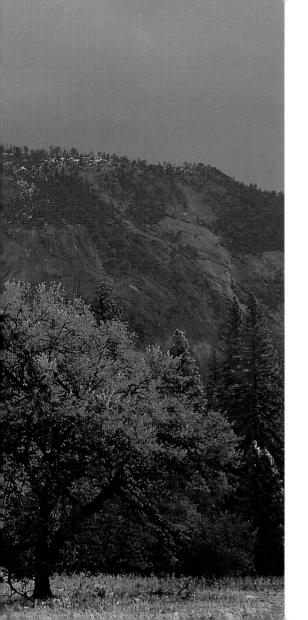

Clearing fall storm over Half Dome
from Cooks Meadow
YOSEMITE VALLEY

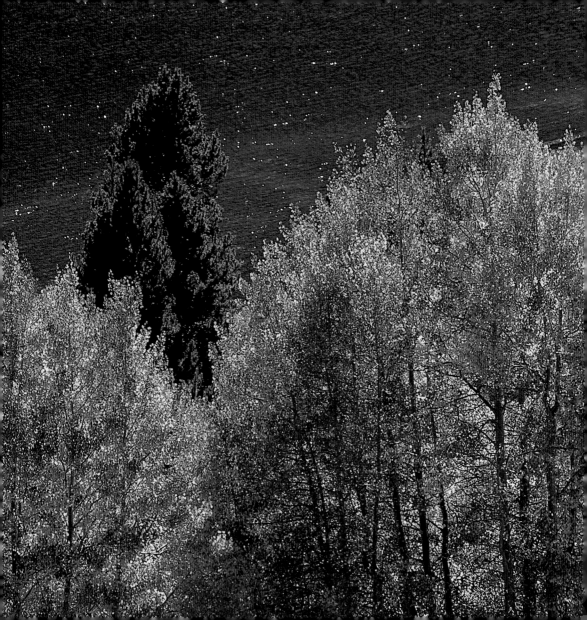

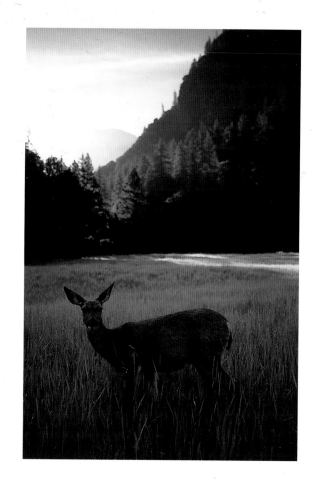

Deer in spring meadow
YOSEMITE VALLEY

Fall colors on aspen trees at Rock Creek Lake (*opposite*)
ROCK CREEK CANYON, EASTERN SIERRA

Wonder, delight, freedom, adventure, excitement, are as much a part of the mountains as peaks and forests. Realism is for tamer landscapes; the mountains are inescapably romantic.

—WALLACE STEGNER

Alpenglow at sunset
on Clouds Rest
YOSEMITE

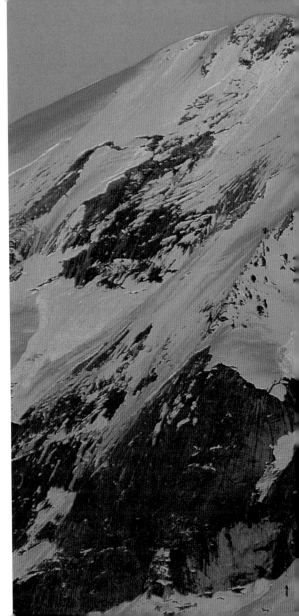

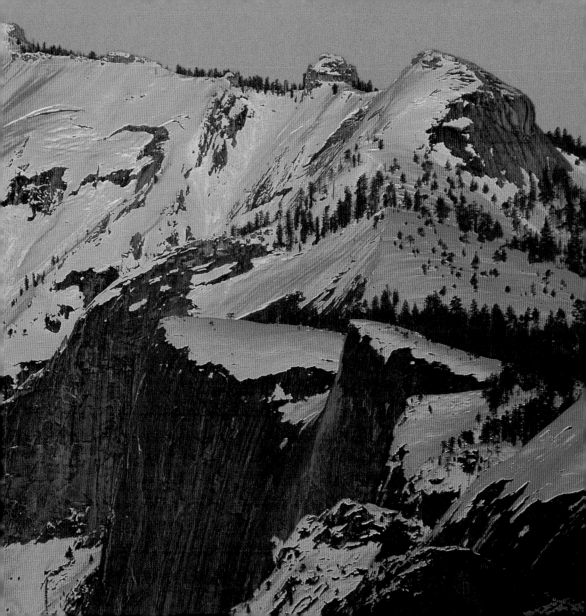

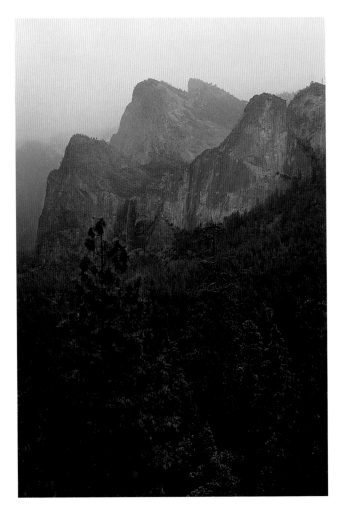

Stormy sunset during November rain from Tunnel View
YOSEMITE VALLEY

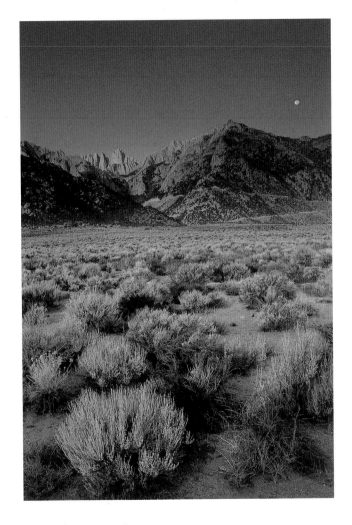

Moonset at sunrise over the Eastern Sierra
EASTERN SIERRA

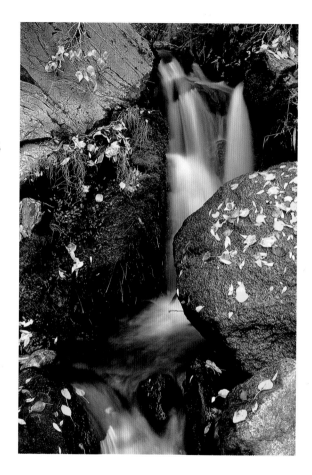

Sunset light
on Cathedral Peak
YOSEMITE

**Fall colors along a stream
near June Lake** (*opposite*)
EASTERN SIERRA

Forest fire smoke cloud
turns red at sunset
over Potter Lake (*overleaf*)
NINE LAKES BASIN
HOOVER WILDERNESS
EASTERN SIERRA

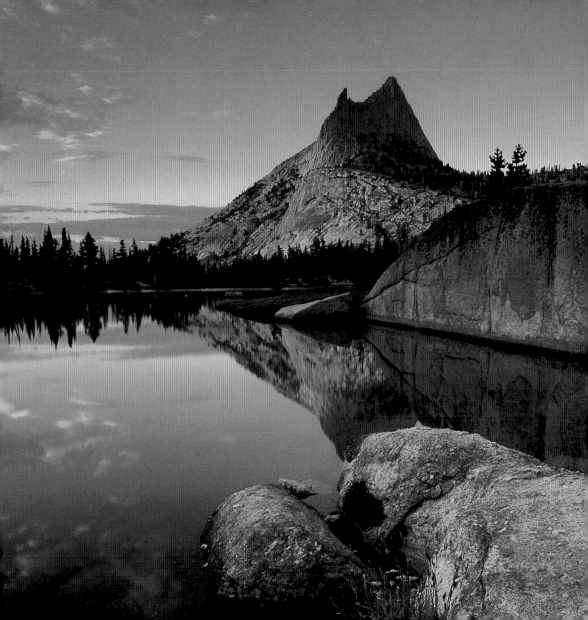

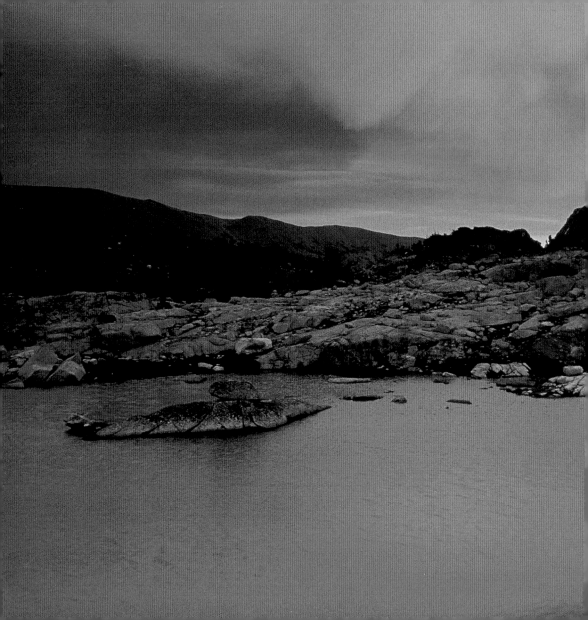

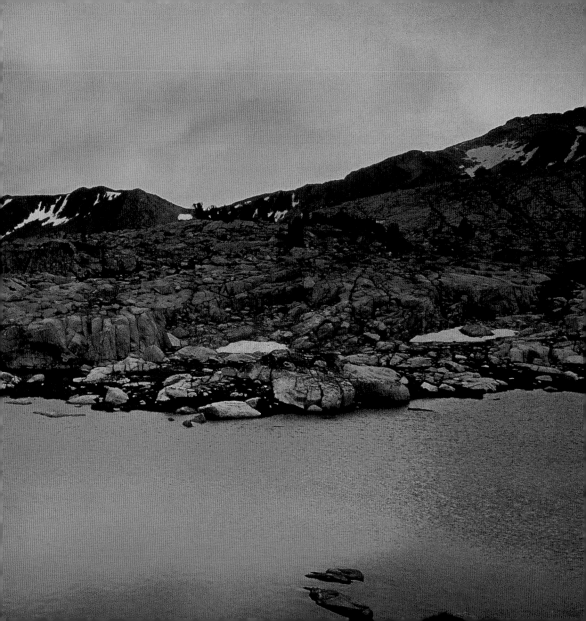

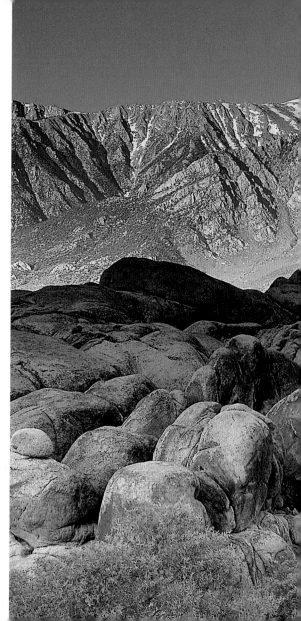

The tranquil uplands where exhilarating air and a free far outlook are combined with the loveliest of the flora. In that zone below the ice and snow and above the darling woods…perfect quietude is there, and freedom from every curable care.

—JOHN MUIR

140

Morning light on the Eastern Sierra from the Alabama Hills

NEAR LONE PINE
EASTERN SIERRA

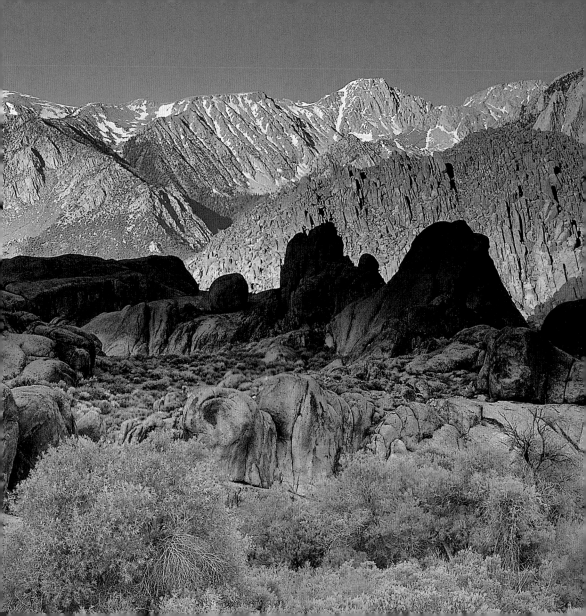

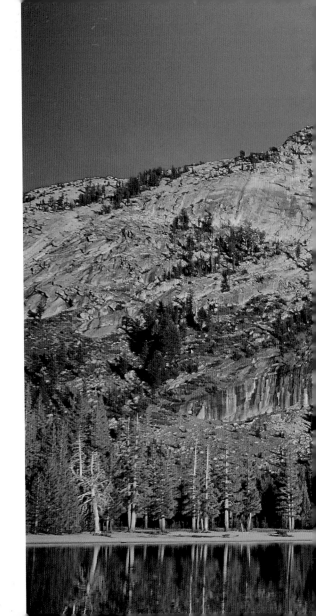

142

Sunset on Tenaya Peak
and Tenaya Lake
YOSEMITE

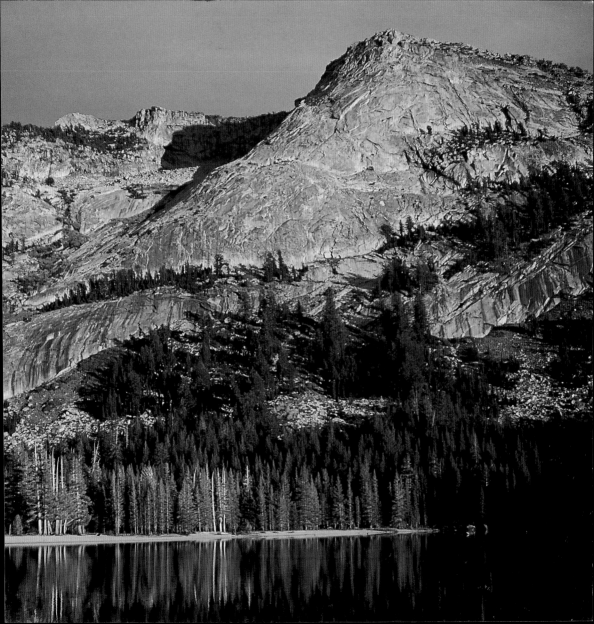

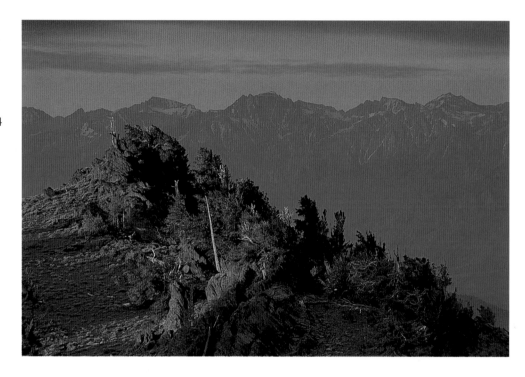

First light on Bristlecone Pines and Sierra from the Ancient Bristlecone Pine Forest
WHITE MOUNTAINS

Backlit cliffs looking up toward Glacier Point from Yosemite Valley *(opposite)*
YOSEMITE

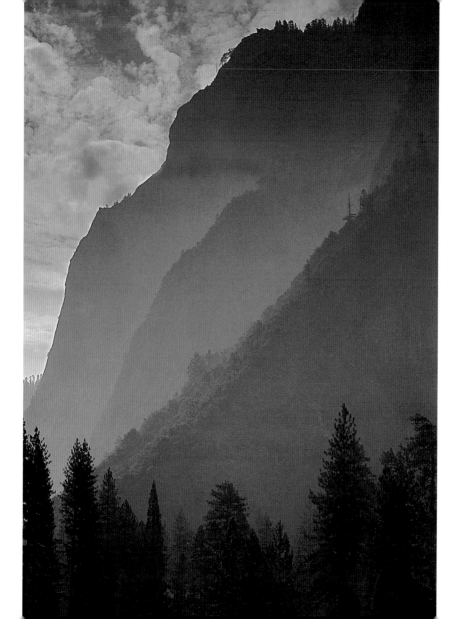

146

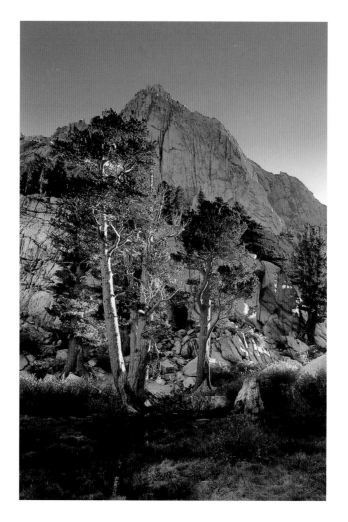

Jeffrey Pines at sunrise below Thor Peak

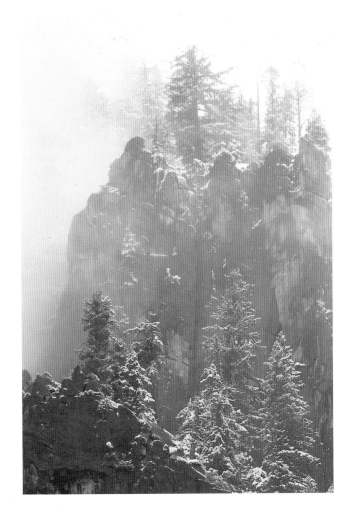

Trees and rocks in winter storm
ABOVE YOSEMITE VALLEY

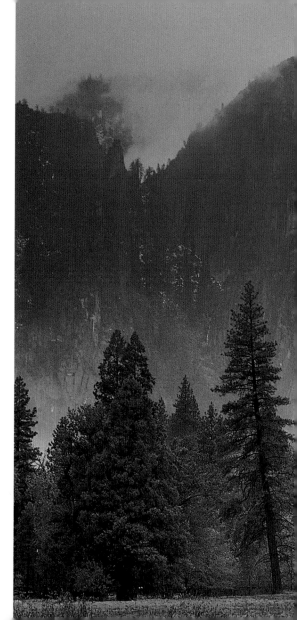

Y osemite
scenery stuns, even overwhelms
148 the senses. Nowhere else is
nature so monumentally
present.

—DAVID ROBERTSON

Fall rain clouds over Yosemite Valley
YOSEMITE

**Alpenglow on storm clouds at sunset
reflected in Potter Lake** *(overleaf)*
HOOVER WILDERNESS

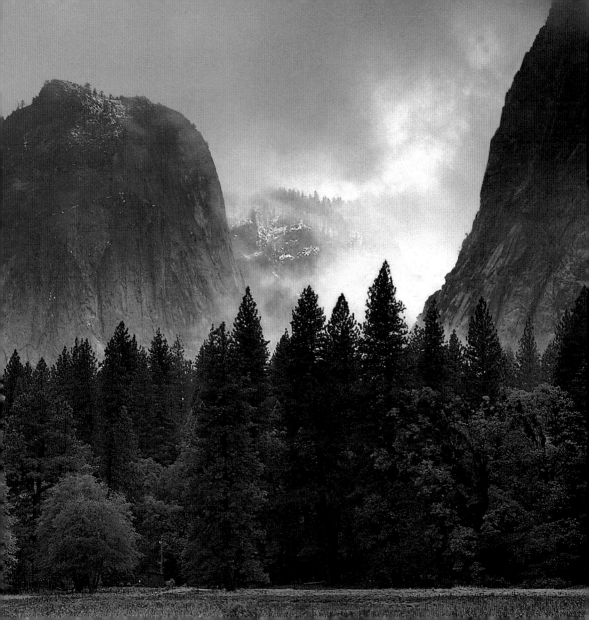

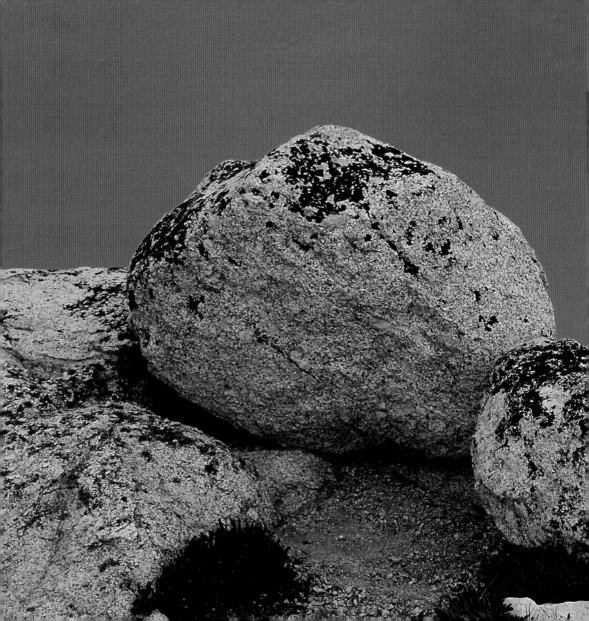

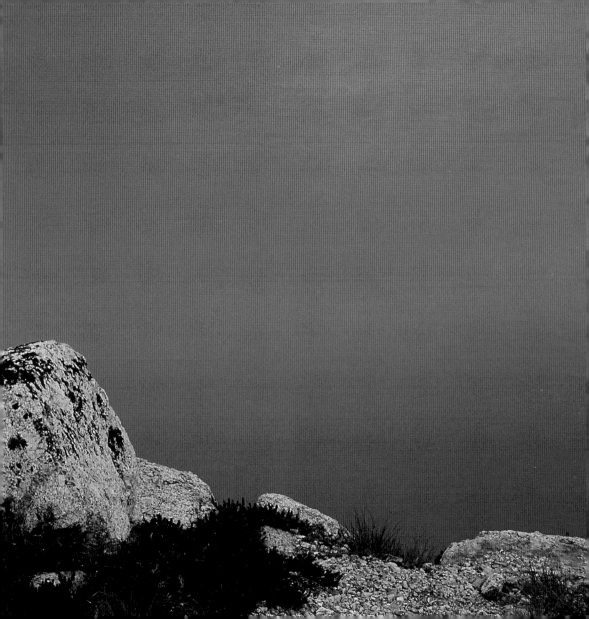

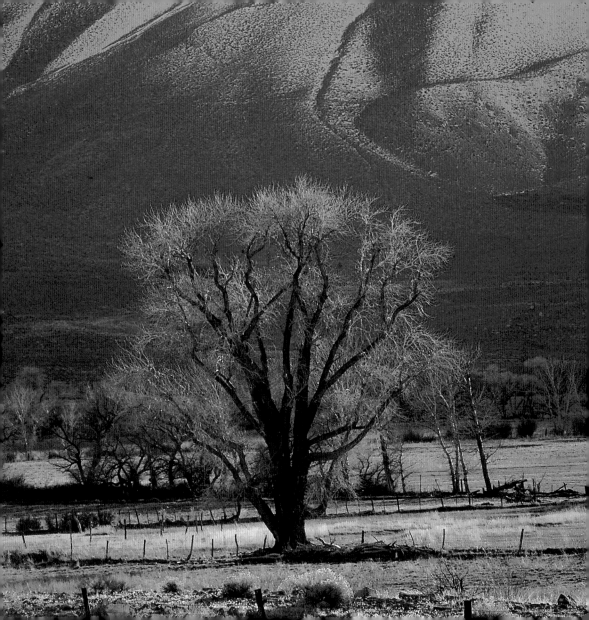

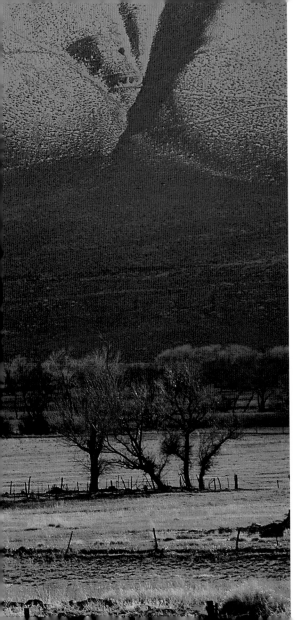

To be alert for
its openings, for that moment 153
when something sacred reveals
itself within the mundane, and
you know the land knows you
are there.

—BARRY LOPEZ

Cottonwood tree in winter
NEAR BISHOP, EASTERN SIERRA

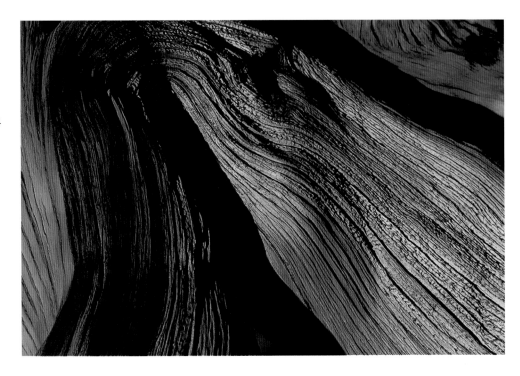

Bristlecone Pine at sunset
ANCIENT BRISTLECONE PINE FOREST
INYO NATIONAL FOREST, WHITE MOUNTAINS

Merced River in spring *(opposite)*
YOSEMITE VALLEY

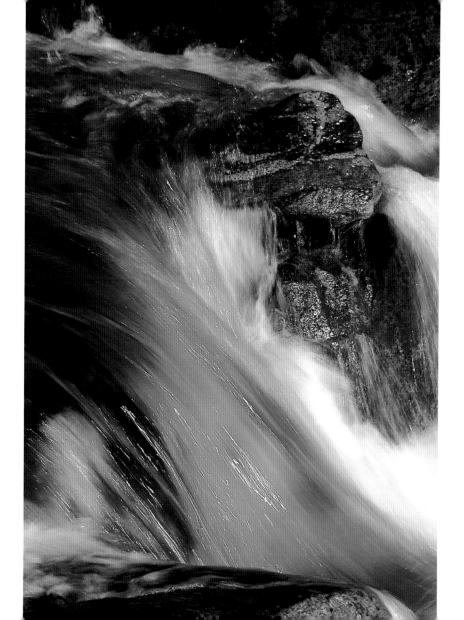

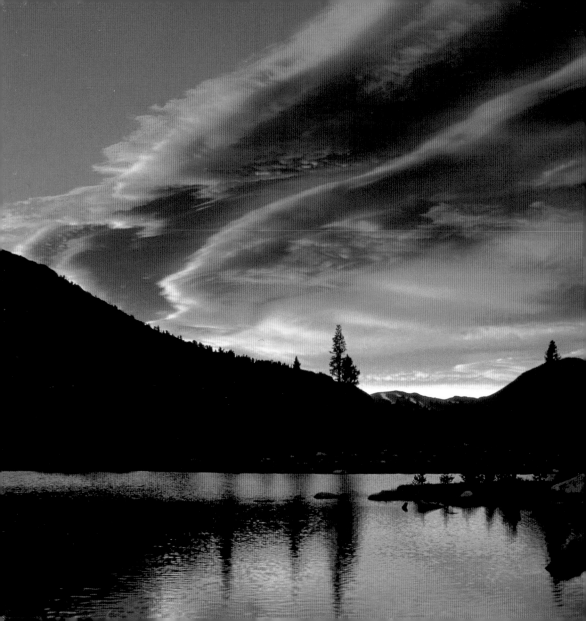

Our ability
to regenerate ourselves
emotionally and spiritually
depends on the existence of
places such as Yosemite, where
we can witness the glory of
nature and partake of its power.

—DAVID ROBERTSON

Lenticular wave cloud
at sunset over an alpine tarn
TIOGA PASS, YOSEMITE

Published in 2004 by Welcome Books®
An imprint of Welcome Enterprises, Inc.
6 West 18th Street, New York, NY 10011
Tel: 212-989-3200; Fax: 212-989-3205
www.welcomebooks.com

Publisher: Lena Tabori
Editor: Peter Beren
Art Director: Gregory Wakabayashi
Designer: Naomi Irie
Project Director: Natasha Tabori Fried
Editorial Assistant: Bethany Cassin Beckerlegge

Distributed to the trade in the U.S. and Canada by
Andrews McMeel Distribution Services
Order Department and Customer Service (800) 943-9839
Orders-Only Fax (800) 943-9831; PUBNET S&S San Number: 200-2442
In Canada: Toll-free (800) 268-3216; Orders-only Fax (888) 849-8151

Compilation and Design © 2004 Welcome Enterprises, Inc.
Photographs © 2004 Gary Crabbe/Enlightened Images
www.enlightphoto.com

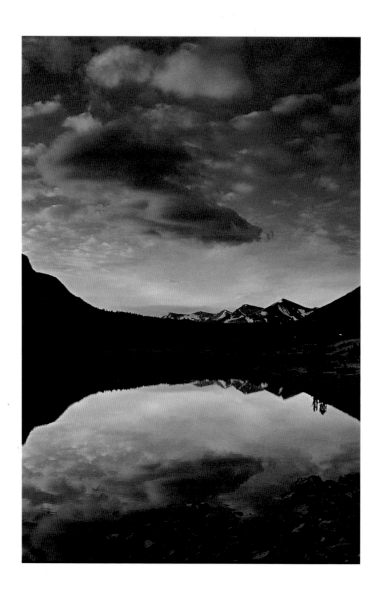